IN TRUE COLLABORATION, DRIVE TRANSCENDS COMPETITION AND BECOMES A UNIFYING FORCE.

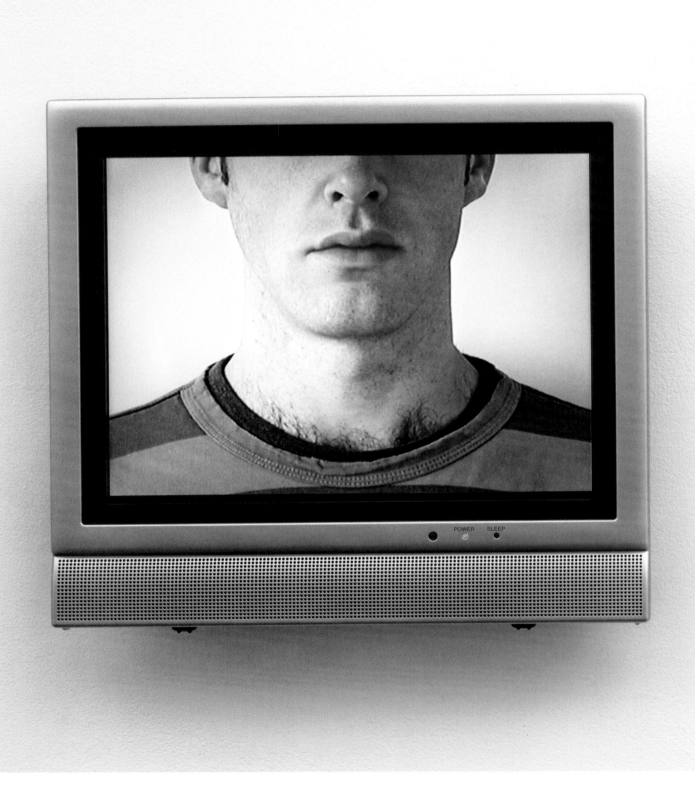

Stand (face), 2002–03
Two-channel video installation,
24 in. x 30 in.
Purchased with funds from an
anonymous donor and Andrea
Feldman (PA 1983)
Addison Gallery of American
Art, Phillips Academy, Andover,
Massachusetts 2003.23

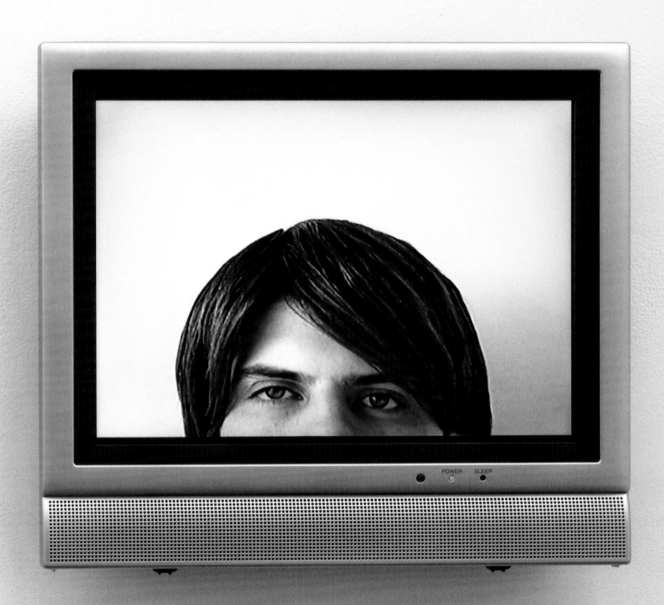

FOREWORD

Modern observers are accustomed to experiencing the art of our time in the prescribed contexts of art galleries, museums, public spaces, and the media. Those experiences normally default to familiar responses, such as admiration, puzzlement, mirth, or consternation.

One of the many virtues of the work of Adam Ames and Andrew Bordwin—who work collaboratively as Type A—is that neither the contexts for nor the responses to their work are prescribed or familiar. Ames and Bordwin slip playfully through the crowded field of art-world protagonists. They resist definition, cajole us with their winning manner, and plough new terrain in ways that are, by turns, mystifying, uncomfortably familiar, and winsome.

The Indianapolis Museum of Art (IMA) is very fortunate to have benefited from Ames's and Bordwin's creativity on our campus. Their project—one of eight inaugural works commissioned for the opening of 100 Acres: The Virginia B. Fairbanks Art & Nature Park—grew organically from the introduction of team-building experiences to a material result, *Team Building (Align),* that museum fetishists like the undersigned can appreciate. And, in the process, a few lucky staff members traveled a memorable path of collaboration with the artists.

My thanks go to both artists for their contributions and to their champion, Lisa Freiman, the IMA's chair of contemporary art. Freiman's aptitude for nurturing talent is unmatched, and her vision for 100 Acres will reward hundreds of thousands of visitors in the coming years. Her planning and able coordination of this project, and the dedication of numerous staff members working alongside her, have brought the museum and our city a memorable and provocative place for independent artistic contributions. We are indebted to the artists, curators, registrars, conservators, educators, and technical staff who worked together to launch 100 Acres with such brio, imagination, and lasting effect.

Maxwell L. Anderson
The Melvin & Bren Simon Director and CEO
Indianapolis Museum of Art

ACKNOWLEDGMENTS

I start by thanking my husband, Ed Coleman, and my daughters, Michaela and Tess, for their flexibility, understanding, and support. My world is enriched by them, and I am fortunate to have both a beautiful, loving family and a challenging intellectual and creative life.

This project was born at the Getty Foundation's Museum Leadership Institute (now located at Claremont Graduate University in Claremont, California), and particular thanks are due to its extraordinary director, Phil Nowlen, who gave me a life-changing opportunity to think deeply about leadership and the art of team building for three solid weeks without family or museum responsibilities during July 2007. Nowlen tasked me with developing a strategic initiative that I would bring back to the Indianapolis Museum of Art to implement. At the time, I wondered what I could do as a curator and park director that would have strategic reverberations for the museum. How could art or, more specifically, my leadership of art projects and relationships with artists make a difference to the museum, the community, and the field? I wanted to function as an activist *within* the museum, to place the artist and museum in collaboration with the public, rather than having these various players at odds with each other. At the same time that I was asking these questions at the Getty, Type A was considering similar ones in relation to their own artistic practice at High 5 Adventure Learning Center in Brattleboro, Vermont.

My collaboration with Adam Ames and Andrew Bordwin—which began unexpectedly in 2006 when the IMA hosted the touring exhibition *Will Boys Be Boys?*, curated by Shamim Momim, which included their work—has been demanding, expansive, and gratifying. I dedicate this book to Type A, to my dear friends Adam and Andrew, with thanks for their openness, with admiration and respect for their rigorous professional practice, and with sincere, unmitigated love for their persons.

The IMA is a source of creative energy and encourages bold experimentation, thanks to the leadership of its Board of Directors and Maxwell L. Anderson, The Melvin & Bren Simon Director and CEO, an unbounded, visionary intellectual enabler who attracts like-minded souls. Anderson has taught me much about the endless potential for vibrant innovation in museums, and I am fortunate to have his guidance, support, and trust. Sue Ellen Paxson, deputy director of collections and programs, has been an advocate, friend, and strategic ally since I started at the museum. She has helped shepherd the IMA's contemporary program and its 100 Acres: The Virginia B. Fairbanks Art & Nature Park. David Chalfie, director of exhibitions and public programs, is a dear friend and confidante, who always asks the practical questions and ensures that we have the right answers. Jane Graham, the senior publications editor, has been a steady, patient, experienced guide. My team in the contemporary department—Gabriele HaBarad, Sarah Green, Allison Unruh, and my dedicated curatorial intern Amanda York, all of whom helped with this project and book in countless ways—is a source of inspiration and joy. I can't imagine a harder-working, more easygoing team, always willing to step up and face the challenges that we dream up. Dave Hunt, the project manager for 100 Acres, has been smart and agile, the kind of brilliant, innovative manager who needs no direction and never disappoints. Lindsey Lord, the IMA's assistant registrar and tzarina of contemporary commissioned projects contracts: Thank you for your patience and perseverance. Mike Bir, our installation designer has added important insight and perspective to this project. Tascha Horowitz, who coordinated all of the digital imaging for this book, and Tad Fruits, the talented, devoted director of photography, who has been both a Type A team member and lead photographer: Thank you for your dedication. Richard McCoy, IMA associate conservator of objects and variable art, took on this project as an opportunity to push the limits of conservation knowledge, to learn, to document the expectations and thoughts of artists, and to understand their ideas about allowable parameters of change. The IMA's extraordinary new media team, the Nugget Factory (Daniel Incandela, Danny Beyer, Dan Dark, and Kate Franzman), continues to push international expectations in the arena of new media and how it can be used with integrity in museums and education. Katie Zarich, director of public affairs, and Ilana Simon, of Resnicow Schroeder, have been tireless advocates of the project, making sure that it would reach a broader public. Meg Liffick: Thank you for your

skills and aplomb. Chad Franer, Chris DeFabis and Mark Zelonis, invaluable experts on the Indiana landscape, have helped us navigate site-specificity in the Art & Nature Park in nuanced ways. Mindy Summers: Thank you for keeping the staff and community safe and secure with regard to all things 100 Acres-related.

Robert Goff and Cassie Rosenthal: Thank you for your support of Type A and your assistance with this catalogue.

Many others deserve my gratitude: Nicholas Fraser, a talented artist in his own right and studio manager for Type A; High 5 Adventure Learning Center, particularly Jim Grout and Jen Stanchfield; and the interdepartmental IMA/Type A team, both past and present: Danny Beyer, Mike Bir, Jed Buxton, David Chalfie, Kimberley Coleman, Tammy Couch, Brad Dilger, Chad Franer, Tad Fruits, Pam Graves, Sarah Green , Gabriele HaBarad, Dave Hunt, Jan Hutchings, Jyl Kuczynski, Judi Kueterman, Meg Liffick, Lindsey Lord, Sarah Martin, Laura Pinegar, Rhett Reed, Tariq Robinson, Kristi Stainback, Allison Unruh, and Hélène Gillette-Woodard. Special acknowledgment goes out in memory of Ursula Kolmstetter, the IMA's former head librarian, who passed away in June 2009. It would have been an honor and pleasure to have had her catalogue and shelve this book in our museum library. Her energy and thoughtfulness are greatly missed.

I am also grateful to the book's designer, Anja Lutz, and the hard-working team at Hatje Cantz, particularly editor Julika Zimmermann, who was especially helpful and patient throughout, and to editor Melanie Eckner and production manager Angelika Hartmann.

Aside from its design and photography, a book is little without its intellectual content. Richard Klein and Ian Berry, two amazing curators and writers, have added a degree of seriousness, insight, and depth to this publication, for which I will always be grateful.

To all of you and many others, it takes a devoted, heterogenous, ingenious team to create innovative aesthetic experiences that matter. Thank you beyond words.
Lisa D. Freiman

Type A owes a great many thanks to a great many people: Sara Meltzer, who introduced us and represented us for several years—and who dubbed us "Type A" during a lunch at Jerry's; Debra Singer (who let us use her name to get a foot in the door with Joel Lieb) and Lauren Ross, who curated us into the Hang Time exhibition; Joel Lieb, who offered us our first representation and solo exhibitions at Ten in One Gallery; Omar Lopez-Chahoud, a wonderful artist and curator who included us in several exhibitions; Henry Urbach, who not only gave us some of our first, intense feedback but also exhibited our work at Henry Urbach Architecture and in one of Exit Art's mammoth shows; Frank Robinson and Andrea Inselmann, who supported our practice very early on at The Herbert F. Johnson Museum of Art at Cornell University; Amy Cappellazzo, for including us in the *Making Time* exhibition (along with Nauman and Warhol and Acconci and Baldessari . . .); Julie Joyce, who curated our solo exhibition *Type A: The Pre-Career Retrospective* at California State University's Luckman Gallery; Bill Arning, for writing about us and giving us shows both very early in our career and recently as well; Shamim Momin, for inclusion in the Independent Curators International (iCI) exhibition *Will Boys Be Boys?* (a show that begat more shows and many, many opportunities); Alyson Baker and Robyn Donohue, for giving us the chance at Socrates Sculpture Park to realize a completely new direction; Kevin Biebel at J. Frederick Construction, for fabricating *Prize (folly)* and giving us anecdotal information that spurred our fascination with anti-terrorism devices and the hardening of urban structures; Miki Garcia, who curated our solo exhibition *Contender* at the Santa Barbara Contemporary Arts Forum; Dominic Molon, for a great catalogue essay, "Two Men, On," and discussions surrounding art, music, and bourbon; Connie Purtill, for his stunning *Contender* catalogue design and all-around wisdom; Adam Weinberg, for his support of our work while at the Addison Gallery (and beyond); Allison Kemmerer and Julie Bernson, for offering and facilitating our residency at the Addison Gallery of American Art; Cassie Rosenthal and Robert Goff, our current gallerists, for their incredible faith in us and whose support has been crucial to our exploration and realization of projects that are unorthodox for a commercial gallery setting; Harry Philbrick and Richard Klein, at The Aldrich Contemporary Art Museum, for their initiation and tireless support of the *Barrier* project; Ian Berry, at the The Frances Young Tang Teaching Museum and Art Gallery, for his curatorial support in general and involvement in the *Barrier* project;

Dina Deitsch, Nick Capasso, and Dennis Kois at the DeCordova Sculpture Park and Museum, for their support and enthusiastic involvement in the *Barrier* project and its accompanying exhibition; Jim Grout and Jen Stanchfield and all at High 5 Adventure, for their guru-like help in training and guiding us in our mission to be bona fide facilitators in experiential education and for helping us become better people; everyone on the IMA Team, for their participation and intense engagement in the (two years and counting) *Team Building* project; Erinn McCluney and the staff at Butler University, for allowing us to realize an ambitious and unusual project and supporting (both figuratively and literally) all members of the IMA Team on the challenge course; Nick Fraser, for being not only a kick-ass artist but also the unofficial third member of Type A. Without his skill and enthusiasm, much of our work would never be realized; Mike Berlin, for his crazy Photoshop skills and all-round can-do attitude. He set the bar for assistantship very, very high; Todd and Randy Domeck, for their involvement in the design and fabrication of *Team Building (Align)*. Their willingness to take on a project for which they had no precedent is inspiring; Brian McCutcheon, an amazing artist who has shown unwavering dedication and tireless effort in fabricating many of our sculptures; Mike Karmody, who successfully fabricated the *Barrier* pieces through hard work, innovation, and sheer determination. His ability to wax eloquent about concrete, art, and politics all in the same sentence has kept us on our toes; Tim Halle, for setting up our studio sound system, collecting our work, and showing us the Path of Righteousness; Ben Diep, the amazing digital printer whose technical and aesthetic skill has helped our photographic practice evolve; The Photography Department at Parsons, The New School for Design, for allowing us to warp the tender minds of young artists since 2002; Dr. Alex Eingorn, for adjusting our spines countless times after strenuous art-making over the years; all the intrepid men of Rocketry Club™, for their courage, determination, and questionable judgment; Café Café, Chelsea Commons, and The Half King, for being our "usual" since 1998.

And to Lisa Danielle Freiman, who changed our practice and, quite simply, our lives. Your unconditional support and deep understanding have inspired us to be better artists and to evolve as people. Your tireless efforts have also challenged us to work harder, delve further into our ideas, and reach new heights we couldn't imagine. Thank you.

Type A

To my fellow artists, who share in the bizarre struggle to realize the ideas, images, and sounds that reside in our heads. To all the curators, directors, gallerists, and collectors who have shown support or offered advice or exhibitions and generally believed. To all my friends who ever listened to me ramble on (whether they wanted to or not) about some half-baked idea, only to have it be completely different when they saw the final piece. To Sara: We built our personal and professional lives together regardless of where the future takes us. To Stella and Max, who are my biggest and most strenuous challenge (who show no sign of letting up). Finally, to all the members of my immediate family, for all of their support in my creative endeavors. Without your support, I could never do what I do. And that would be unthinkable.

To Andrew: I could not ask for a better collaborator and friend. Our relationship has been and continues to be the cornerstone of my aesthetic and personal growth. Though it began by chance, it continued through chemistry, commitment, and determination. I am thankful for our past and future challenges. Our lives are forever intertwined, both in and beyond the challenges of Type A.

Adam Ames

First things first: Thank you, Adam, for asking me to work with you, and for endless friendship, support, understanding, and your rigorous work all these years. We started shooting a video and ended up sharing a life in every way imaginable. This whole thing started by chance and grew thanks to the freedom, confidence, and keen perspective given without reservation by my wife, Gaby Bordwin. Tamar Mia was born fourteen months after Adam and I started working together and Zoe Rose three years after that, so they've never known a world without Type A. Their placid reactions to even the most outlandish projects we've done have been a source of amusement and encouragement to me. My friends have been a constant source of support and perspective, and I could not do any work without their community. My father has always been my hero, but he is now more than ever. He and my mother never hesitated in supporting my direction. She was a great artist and understood my desire to make work. I dedicate this book to her loving memory.

Andrew Bordwin

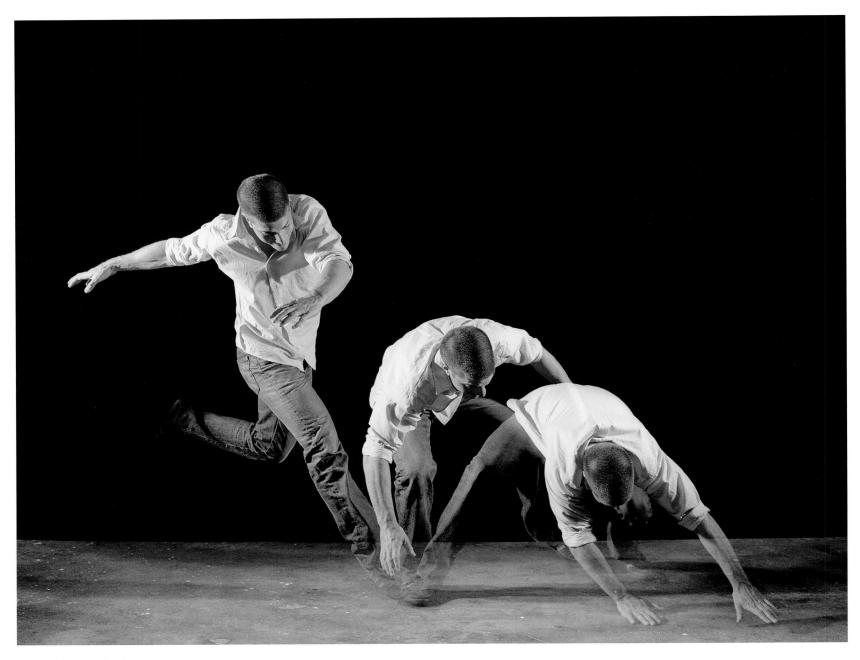

Untitled (AA<—>AB/3–1),
from the *Push* series, 2004
Chromogenic prints,
20 x 24 in. (each)

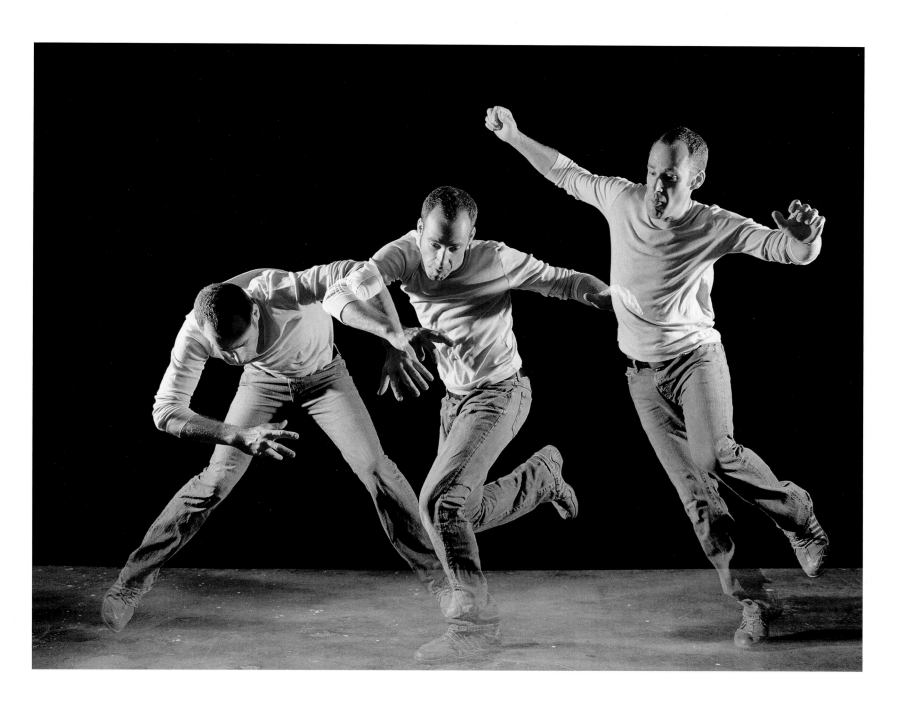

THE DESIRE WAS THERE TO BRING PEOPLE INTO WHAT WE DO AND TO EXPAND BEYOND JUST THE TWO OF US.

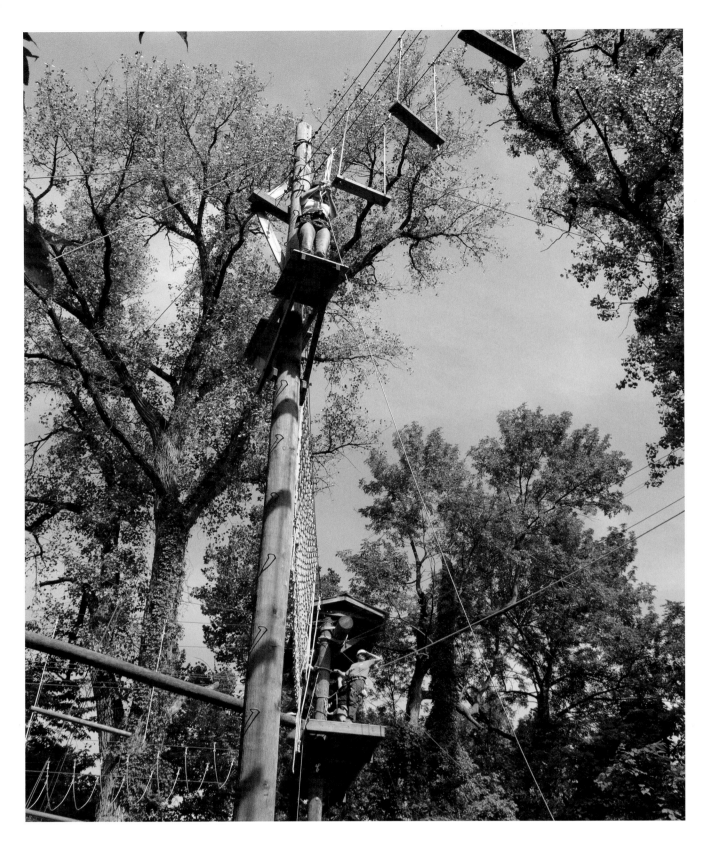

{fig. 1} The author on the high ropes course at Butler University, September 19, 2008

TYPE A'S ALIGNMENT

LISA D. FREIMAN

"I need to have stress and tension in order to feel like I'm growing."
"One's challenger can also be one's most valuable partner."
"We wanted to bring . . . people into what we do . . . and actually to expand beyond just the two of us." [1]

I can't look down. Forty feet up in the air, I am terrified, stuck in the middle of Type A's *Team Building* project. I can't move. My hands are gripping the ropes so tightly, my knuckles look like ice. I *can't* let go. The cables and wooden steps are swinging precariously; they are placed too far apart for me to move along safely from one to the next. I am paralyzed and sick with fear {fig. 1}.

I hear a voice: "Lisa, I'm right here." Adam Ames has climbed up behind me. "You can do this," he says. I look ahead at the many swinging steps that I must traverse. I still can't move. One of the ropes course facilitators is sitting on a platform at my temporary destination, slowly coming into focus. Suddenly, I remember this feeling: the terror and adrenaline that come with fierce, unrelenting contractions as I am trying to deliver my first baby without drugs. And that nurse in blue scrubs says: "The only way through this, honey, is to push her out."

I say to the facilitator: "I recognize you: you're the labor and delivery nurse!" He looks at me quizzically, but smiles warmly, and I prepare to take the next step.

How do I write about my collaboration with Type A over the past three years? When a project is conceived between an artist and a curator, where do authorship and participation begin and end? What are the boundaries between two artists, between artists and a curator, between a collaborative and a broader public? My partnership with Type A, the artist duo composed of Adam Ames and Andrew Bordwin, has raised complex questions about the definitions of identity, intimacy,

1| The quotations, in order of presentation, are from Adam Ames, in Type A interview with the author, September 5, 2008; Jessica Ostrower, "Type A at Sara Meltzer," *Art in America* (December 2003); and Andrew Bordwin, in Type A interview with the author, September 5, 2008.

power, individuality, and collaboration. Risk has always intrigued me, and something about Type A made me feel that it was safe to explore it with them professionally. In late 2006, I invited the artists to develop a project for the Indianapolis Museum of Art's 100 Acres: The Virginia B. Fairbanks Art & Nature Park. What began as an invitation based on intuition evolved into a provocative and extraordinary aesthetic and intellectual investigation.

Allowing my intuition to rule in this situation was a struggle. As a trained art historian, I have been taught to anchor my observations objectively. But something about Ames and Bordwin made me want to let go and see what would happen if we moved together into the realm of the unknown. I don't use the word *intuition* here lightly. Intuition is a feminized construct and, as such, this concept is a curious way to begin a monographic essay about two artists who place the exploration of masculinity at the center of their artistic practice. As a woman, I have introduced a new variable into Type A's two-man haven. How does my own role in their *Team Building* project intersect with Ames and Bordwin's long-standing investigation of the politics of collaboration? How does it relate to the way their practice has developed and transformed, moving away from an investigation of collaboration between two men to a broader, more nuanced understanding of public collaboration?

In the spring of 1998, Adam Ames asked his new friend Andrew Bordwin to help him shoot a video. Ames, a self-professed music and film buff, had worked as John Coplans's studio assistant before receiving a Master of Fine Arts in photography and related media at the School of Visual Arts in New York. Bordwin, who had been trained in classics and photography at New York University, was fascinated by the urban landscape and linguistics and worked professionally as a commercial photographer after playing drums in two touring alternative bands. They had met earlier at a dinner hosted by Ames's future wife, Sara Meltzer, who was showing some Iris prints from Bordwin's series *Collective Memory I* during a salon-style dinner at her home. At that time, Ames was making his own videos, which often focused on violent psychosexual behaviors and fantasies. But in this instance he needed a partner to help him reenact a very specific experience, one which had been unpleasantly evoked by his father's unwitting gift of a framed high school newspaper clipping {fig. 2} that shows Ames being choked by his high school wrestling opponent, with the caption: "Ouch!"

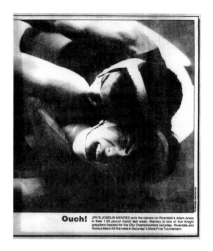

{fig. 2} Adam Ames during a high school wrestling match, *Riverdale Review*, Riverdale Country School, New York

Ames's father insisted that he had recently found the picture and wanted to give it to Ames at a family dinner because he was proud of him, but Ames was embarrassed by the gesture, aware that he was being presented publicly as the victim in a moment of weakness. The psychological tension of that initial encounter between two teenage boys, the re-presentation of it framed at a dinner between father and son, and the re-creation and reconstruction of the experience as an art video form the armature of *Dance*, which originated as an act of revenge in response to Ames's father's "gift."

Dance became Type A's first collaborative work: a re-creation of a memory of a high school wrestling match, where the physical and psychological struggles between two young men, one in blue, the other in red, ensue over the course of five minutes. Their movements are punctuated by deep exhalations, awkward grunts, and interlocking embraces during a competition centered on dominance, humiliation, and the overriding presence of sublimated male desire channeled through the conceit of sports {fig. 3}. *Dance* introduced the primary themes Type A has investigated over the past twelve years: masculinity, competition, bonding, individuality, and collaboration. Bordwin, a third-degree black belt in Aikido,

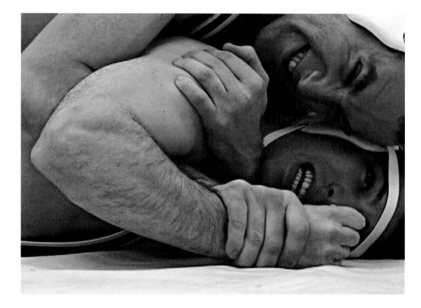

{fig. 3} *Dance*, 1998
Single-channel video, 5:00 min.

was used to physical intimacy and competition, and *Dance* was an obvious first project for the two, a kind of icebreaker to kick off their relationship. The project signaled the artists' awareness of how they could manipulate and control the spectator by denying the viewer the satisfaction of witnessing a "good game." Bordwin explained:

Normally, when you have a contest, you've got two sides, and you have a set of parameters, a set of rules, whether it's based on time, place or appearance, and

someone wins and someone loses. And when you make a piece in which there's no back and forth there, you know it's a boring game. People say, "Wow, that was a good game," when, you know, one team gets the lead and then relinquishes the lead—it goes back and forth a bunch of times . . . the whole point is you're engaged in that seesaw and you're engaged in that constant shift of power and advantage. And what started as a kind of hoot, with basically Adam saying, "Kick my ass. No, I'm not asking, I'm telling. Kick my ass," turned into us saying to the viewer: "You don't get that. Sorry you're not allowed . . . there's gonna be no back and forth, there's gonna be no exchange of power, there's gonna be no shifting in that balance at all. It's just going to be incessant, non-stop." . . . Does that make it boring? Or does it actually make you think about what power is?[2]

While there is a palpable amount of tension in the video, during the creation of it Ames and Bordwin were "laughing and having fun, and bonding."[3] After rolling around on the floor together for five hours, they were prepared to try anything. *Dance* featured a major dynamic found throughout Type A's work: the productive nature of discomfort (struggle, confusion, anxiety, stress, and sexual tension) and how it can challenge one to transcend prescribed limits. The new possibilities inherent in collaboration and the resulting creative tension stimulated by *Dance* prompted fresh challenges. While each artist continued with his solo career, it was not long until their collaborative practice began to take priority. By 2004, they had abandoned their separate studios and moved into a shared space in Chelsea on West 26th Street to pursue their collaboration indefinitely.

Type A's work, which incorporates photography, video, drawing, sculpture, and performance, centers on "the ways in which men compete, challenge and play, and the resulting social and psychological imbalance. Documenting predetermined actions toward a series of goals, the . . . works range from psychologically disarming to profoundly absurd."[4] Various critics and curators have compared Type A's work to the Conceptual and performance-based video and photography of artists of the nineteen-seventies, especially Bruce Nauman, Vito Acconci, and Chris Burden.[5] Curator Dominic Molon has written about these comparisons: "In contradistinction to these precedents, which were among the first to incorporate the very new and still crude medium of video, Type A's work possesses a high degree of aesthetic polish and finish, with an at-times

2| Bordwin 2008 (see note 1).
3| Ames 2008 (see note 1).
4| Type A artist statement, www.typea.us (accessed November 12, 2009).
5| See for example: Barbara Pollock, who suggests a connection to Nauman, in "Type A: Mark/Point/Stand," *Time Out*, no. 392 (April 3–10, 2003). Marcel Krenz points to their work's relationship to performance, body art, and earthworks from the seventies in *Contemporary*, no. 50 (2003). Jessica Ostrower compares Type A's video art to "Nauman's compulsive body-oriented video works" in Ostrower 2003 (see note 1). Reena Jana associates Type A with "a boys' club of modern artists whose work is often focused on the body," such as Nauman, Acconci, and Burden, in "Push and Pull," *Art on Paper* 9, no. 1 (September/October 2004), p. 28.

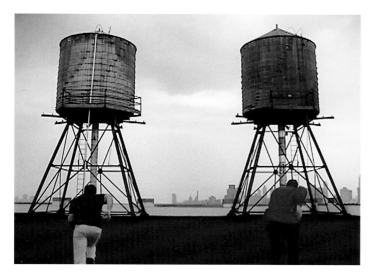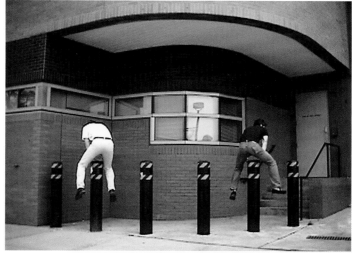

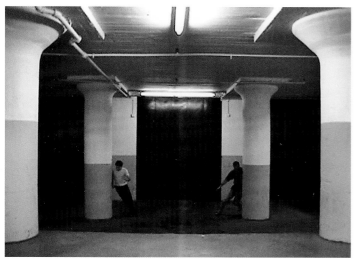

{fig. 4} *4 Urban Contests*, 1998
Single-channel video, 5:10 min.

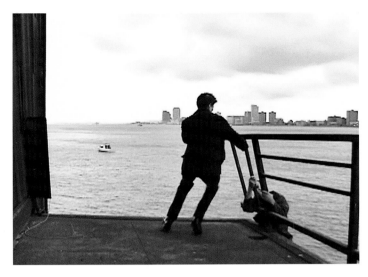

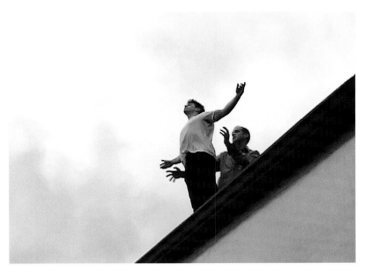

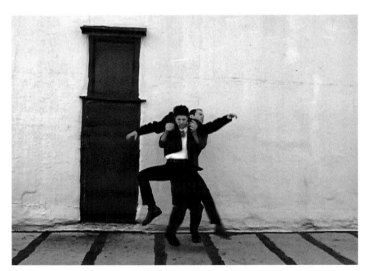

{fig. 5} *5 Urban Rescues,* 1998
Single-channel video, 2:40 min.

cinematic attention to the formal composition of their scenes. In all of these instances the collaborative process introduces a tension based on the dynamic of fusion and dissonance."[6]

The single-channel videos that followed *Dance* in 1998, *4 Urban Contests* {fig. 4} and *5 Urban Rescues* {fig. 5}, similarly focus on male competition, albeit with the introduction of humor and absurdity, and establish what the artists describe as the "basic visual and behavioral vocabulary" for their work.[7] In the former, Type A embarks on four separate urban competitions: a race to two water towers and back, jumping over six barriers, running around hefty industrial columns in an interior loading dock, and a literal pissing contest. Each composition creates "a formal arena in which both figures and structures compete against each other and for the viewer's attention."[8] *4 Urban Contests* is a sincere attempt to develop a list of actions (to run, to jump, to piss . . .) that becomes a kind of formal primer for their practice. *5 Urban Rescues*, the counterpart to *4 Urban Contests*, establishes a different tone. Out in the public urban landscape, the actors self-consciously draw on clichéd representations found in popular action films. In contrast to their sincere embodiment in the performance of *4 Urban Contests*, here Ames and Bordwin appear to be role-playing, acting as surrogates for themselves. Unlike the former, this project works against competition, looking for the first time at collaboration, particularly "generosity, compassion, and selflessness."[9] The artists engage in five brief scenarios, all involving men as victims and saviors in dire situations: suicide attempts, dangerous falling objects, an oncoming train, and a gun shot. The two projects present the interdependent dialectical poles of their work: competition and collaboration.

The gradual shift into role-playing allowed Type A to analyze their own practice at a relatively early stage in their partnership. The *Twins Project* (1998–99), which they developed one year after *Dance*, consisted of custom-designed dolls and

{fig. 6} Images submitted to the My Twinn company for the production of *Twins Project* dolls, 1998

6| Dominic Molon, "Two Men, On: Restraint and Intensity in the Work of Type A," in *Type A: Contender*, exh. cat. (Santa Barbara Contemporary Arts Forum, 2006).
7| Artist statement, *4 Urban Contests*, www.typea.us.
8| Ibid.
9| Artist statement, *5 Urban Rescues*, www.typea.us.

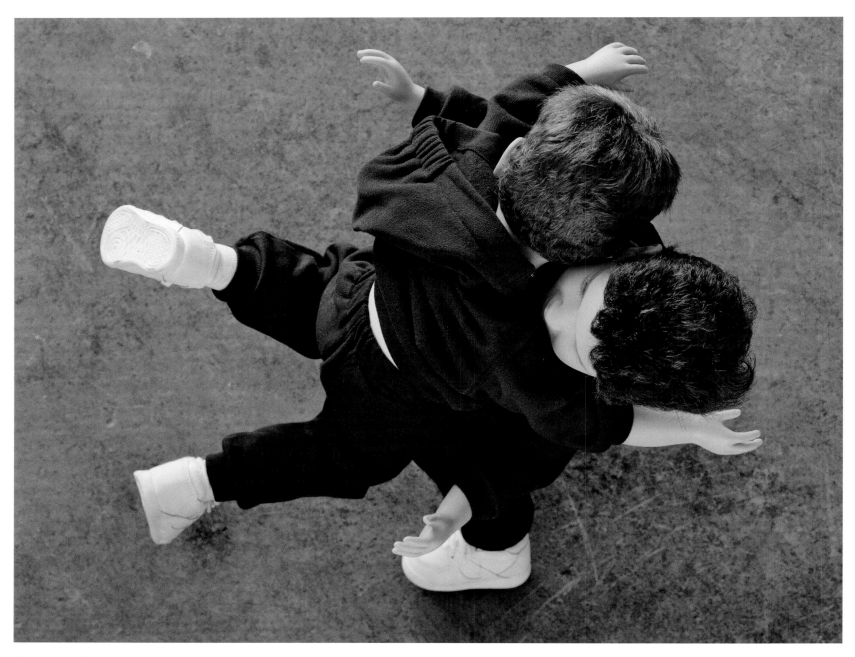

{fig. 7} *Untitled (tackle)* from
Twins Project, 1998–99
Chromogenic print, 30 x 40 in.

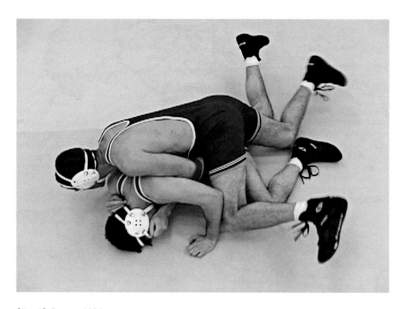

{fig. 8} *Dance*, 1998
Single-channel video, 5:00 min.

chromogenic prints. For this series Type A submitted pictures of themselves to the My Twinn Company, which created dolls fashioned in their own likenesses {fig. 6}. The translation of their adult portraits into dolls that are typically modeled after children ages three to twelve made the dolls' appearances absurd, inaccurate, and uncannily indistinguishable. Ames and Bordwin were not only acknowledging themselves as actors, as they had done in *5 Urban Rescues*, but they were releasing themselves, moving beyond the limits of their own bodies, to manipulate surrogates outside themselves. Once they received the two dolls, Type A began playing with them, arranging and photographing them in various roles reminiscent of the *Dance* stills {figs. 7, 8}. Among the various photographs are five close-up, cropped untitled images *(eye, legs, hood tug, hug, tackle)* and a triptych, *Untitled (Working Together Towards a Brighter Future)* {fig. 9} consisting of two head shots separated by a close-up of the dolls' hands clasped in a congratulatory handshake. The triptych suggests the classic response to fierce competition—good sportsmanship—and recognizes a game well played. *The Twins Project* looks back to childhood role-playing and inverts a stereotypically feminized activity into a metaphoric tool for analyzing masculinity, competition, and collaboration.

While the *Twins Project* incorporates Type A's characteristic sense of humor, it uses regression, a classic tool of psychoanalytic treatment, to work through the main issues explored in their work. Playing with dolls becomes a means to revert to childhood desires and tendencies, to focus on a return to youth, a withdrawal from fully formed adult masculinity, to a moment with fewer demands: "Though competition runs through every element of existence, the demand put upon men to be competitive can be especially severe. This is initiated in childhood

{fig. 9} *Untitled (Working Together Towards a Brighter Future)*, 1998–99
Chromogenic prints, 40 x 50 in. (center);
30 x 40 in. (left, right)

and continually intensified. If one is 'type a,' then these challenges are not only expected but also necessary to the definition of one's character."[10]

Regression, or a metaphorical journey back in time to one's childhood, is meant as a tool for change and healing. Freud believed regression was caused by a longing for male protection.[11] The traumatic wrestling match, originally reconfigured in *Dance* and then revisited in the *Twins Project,* becomes a way to reenact that safe haven of childhood play in order to explore formative moments of male intimacy, competition, aggression, and tension. It also establishes the first moment when Type A began to collaborate with something outside of themselves, in this case their surrogates.

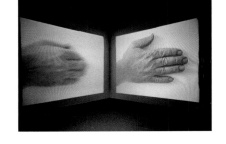

{fig. 12} Dennis Oppenheim, *Echo,* 1973
Four-channel 16 mm films transferred to video, black-and-white, sound, loop, projected simultaneously on four walls; dimensions variable, Whitney Museum of American Art, New York.
Partial gift of the artist and partial purchase, with funds from the Film and Video Committee 2002.85
Photography by David Allison
© 2010 Dennis Oppenheim

Type A takes the handshake gesture presented first in the *Twins Project* and exaggerates it to absurd proportions in the single-channel video *Outstanding* (1999) by allowing the brief action to expand over the course of thirty minutes in a public context. Ames and Bordwin don ubiquitous male attire, the business suits found in Midtown Manhattan {fig. 10}, and stand in front of an office building as passing cars and pedestrians move across the screen between them and the viewer. Their ceaseless, repetitive masturbatory gesture transforms into one suggestive of videos from the seventies, where real time and repetition, channeled through specific actions, form the main subject and medium for investigation. Here the handshake becomes an interrogation of male bonding, something to which Type A returns in 2003 with the two-channel video *Bleed* {fig. 11}. Reminiscent of the formal composition of Dennis Oppenheim's 16 mm black-and-white film *Echo* (1973), which includes four enormous projections of the artist's hand repeatedly slapping the white wall of the gallery {fig. 12}, *Bleed* features two monitors with close-up videos, one of Ames's hand, one of Bordwin's, extended with palms outstretched against a stark gray table. Each artist takes a razor blade and makes a precise cut in the center of his palm, allowing a drop of blood to ooze out. Then the two hands reach across the juxtaposed frames and, in the space between the monitors, they shake; but the union occurs off camera in between the two frames, so that the act of caressing

{fig. 11} *Bleed,* 2003
Two-channel video, 2:10 min.

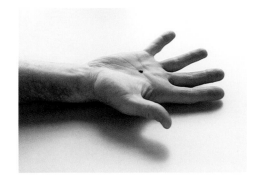
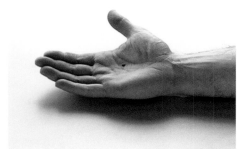

10| Artist statement, www.typea.us.
11| Sigmund Freud introduced the notion of regression in *The Interpretation of Dreams,* Parts I and II, The Standard Edition [SE] of the Complete Psychological Works of Sigmund Freud, 24 volumes, ed. by James Strachey et al. (London 1953–74), pp. 4–5.

{fig. 10} *Outstanding*, 1999
Single-channel video, 30:00 min.

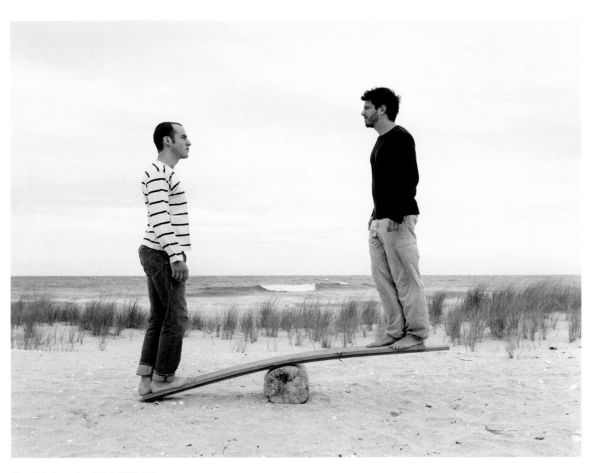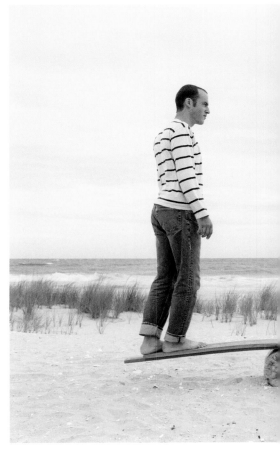

{fig. 21} *Stand (weight)*, 2002–03
Chromogenic prints, 24 x 30 in. (each)

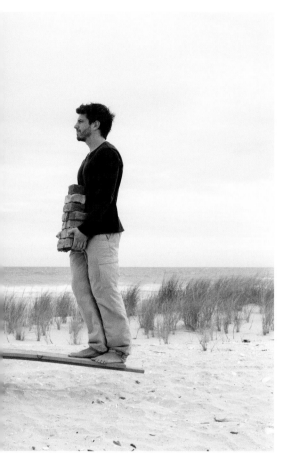
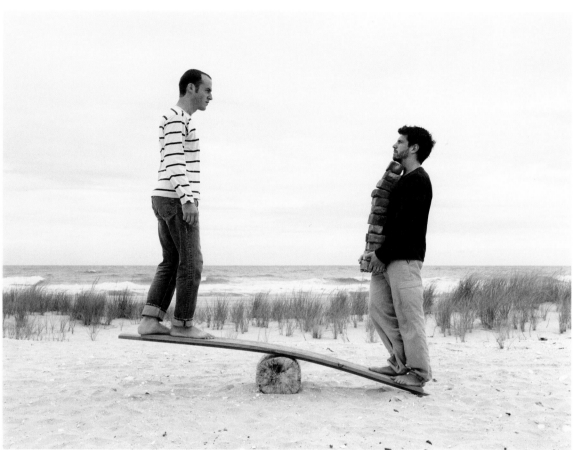

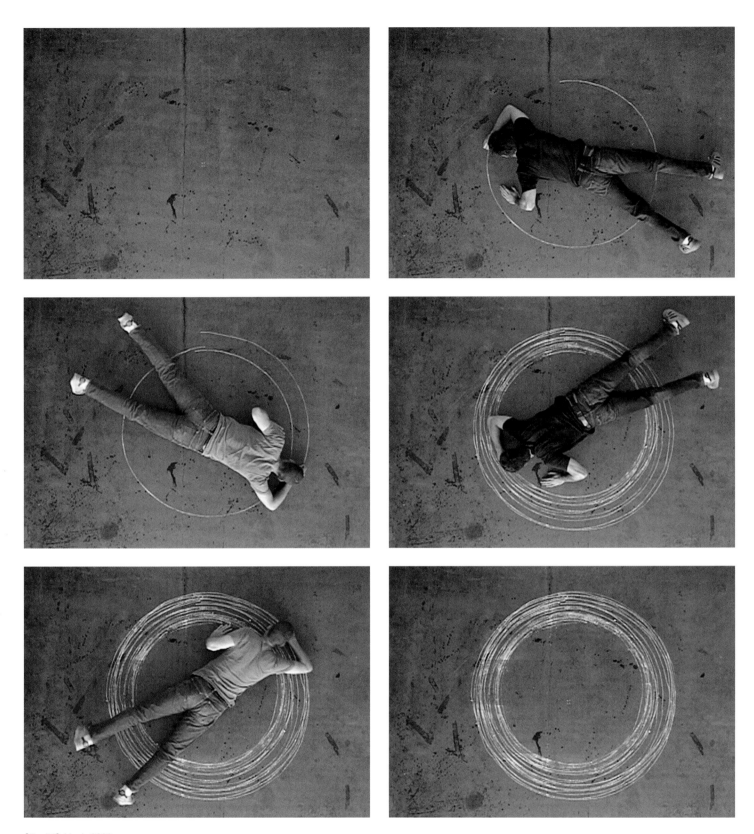

{fig. 15} *Mark*, 2002
Single-channel video, 34:00 min.

each other and exchanging bodily fluids cannot be witnessed directly by the viewer. Although more pared down in form, this work echoes the dynamic action and frustrating content of *Dance*, demonstrating how one person (or collective) can control what the viewer experiences. Type A denies the viewer the satisfaction of witnessing the private climax, just as in *Dance* the artists eliminated the possibility of a reciprocal competition or a "good match."

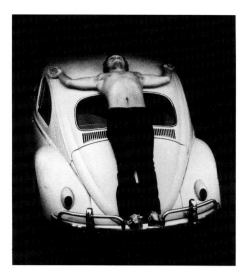

The intimate nature of *Dance*, *Outstanding*, and *Bleed* acknowledges but departs from classic examples of body-based performance. The themes of danger, risk, and pain—which one cannot help but perceive while watching each artist slice open his palm, allowing blood to spill like stigmata—recall Chris Burden's controversial masochistic projects, such as *Trans-fixed* (1974), where he was "crucified" to the back of a Volkswagen {fig. 13}. *Outstanding* and *Bleed* also recall Vito Acconci's infamous *Seedbed* (1972), in which Acconci masturbated continually beneath a gallery-wide platform as he expressed via loudspeaker his fantasies about the Sonnabend Gallery's visitors walking above {fig. 14}. Whereas Acconci's project depended on the visitor's participation, Type A's work refuses the viewer's gaze during *Bleed*'s central moment, reinforcing the private nature of the ritual and reminding viewers that they are not invited.

{fig. 14} Vito Acconci, *Seedbed*, Sonnabend Gallery, NY, January 1972
Performance/Installation: wood ramp 2 ½ x 22 x 30 ft.; 9 days, 8 hours a day, during a 3-week exhibition
Photograph: Bernadette Mayer, © Vito Acconci. Courtesy of the Acconci Studio.

After four years of exploring different approaches to their work, Ames and Bordwin began to think more about interrogating, assessing, and defining the physical and formal parameters of their own competition and cooperation. Three subsequent performance-based projects, *Mark* (2002), *Stand* (2002–06), and *Push* (2004), question the boundaries between the individual and the collective. *Mark*, a project that variously measures the artists' differing heights, is a thirty-four-minute

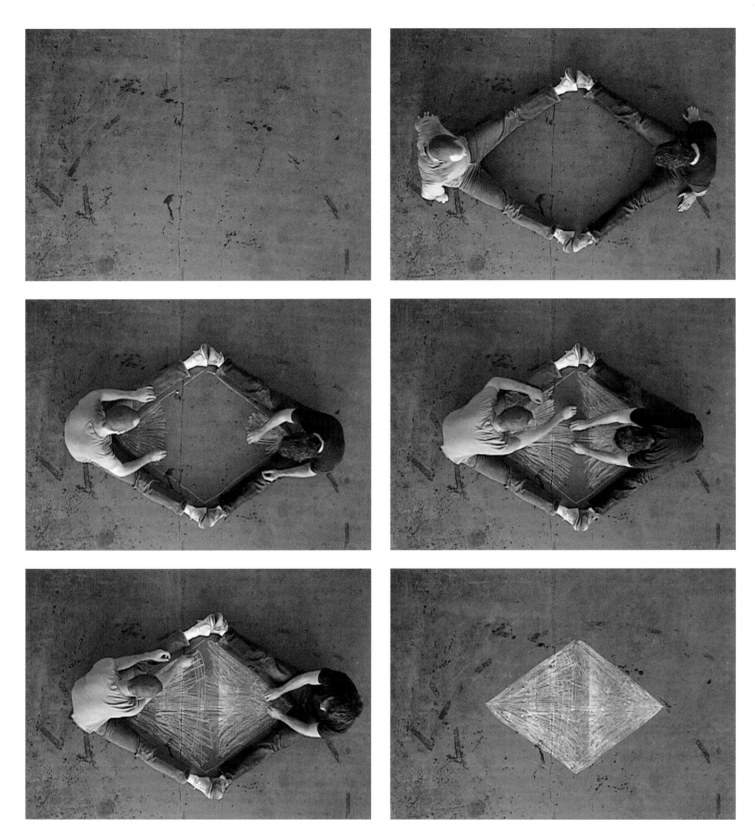

{fig. 16} *Mark*, 2002
Single-channel video, 34:00 min.

single-channel video with corresponding chromogenic prints that picture the final chalk mark traces left by the artists' actions. Shot from above, against the concrete backdrop of the studio floor, Ames and Bordwin attempt to delineate the boundaries of their own bodies, superimposing their tracings in circles of white chalk until the distinction between them becomes blurred {fig. 15}. A jug of water and a squeegee wash away each finished drawing, forming a break between each of the video's three segments and suggesting a definitive erasure, a release of control over individual authorship in favor of the territory of collaborative production. In the second part of the video, the two artists sit on the ground with their legs extended so that their feet touch. Pressed into the shape of a diamond, they mark the shared space between them, creating a geometric metaphor for their union {fig. 16}. Afterwards, they wash away the mark. The final segment shows what Type A refers to as the "entire territory of the medium," or essentially the frame defined by the camera. It is not an individual or shared trace, but a geometric form, a rectangle, that signifies the space of the spectator, whose perception is controlled by the camera frame but acknowledged by the artists {fig. 17}.[12]

Like *Dance, Outstanding,* and *Bleed,* these works point to experimentation with the artist's body in time-based performance art and video, especially Bruce Nauman's 16 mm film *Dance or Exercise on the Perimeter of a Square* (1967–68), which shows him making a square of masking tape on the studio floor, marking each side's midpoint {fig. 18}. To the sound of a metronome, he begins at one corner and systematically moves around the perimeter of the square, each pace the equivalent of half the length of a side of the square.[13] Type A, like Nauman, defines each of their bodies in relation to the size and perimeter of a geometric form; however, in *Mark,* importantly, Type A's traces are integrally related to and reciprocally reliant on each other's physical frame. The final forms could not exist if they were creating the work individually. Interestingly, Bordwin describes *Mark* as the turning point in their practice, the moment when he recognized, like Ames, that their collaborative work was more challenging than what they were doing alone. He explained: "I realized that the work that we were doing together was satisfying my own aims more than I could ever satisfy on my own.

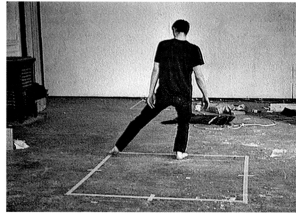

{fig. 18} Bruce Nauman, *Dance or Exercise on the Perimeter of a Square,* 1967–68
16 mm film, black-and-white, sound; approximately 10 minutes
Distributed by Electronic Arts Intermix, Courtesy Sperone Westwater, New York
© 2010 Bruce Nauman / Artists Rights Society (ARS), New York

12| Artist statement, *Mark,* www.typea.us.
13| Type A's work *Mark* will appear along with works by Richard Serra and Nauman as well by other emerging and mid-career video artists in the IMA exhibition *Framed* scheduled for fall 2010.

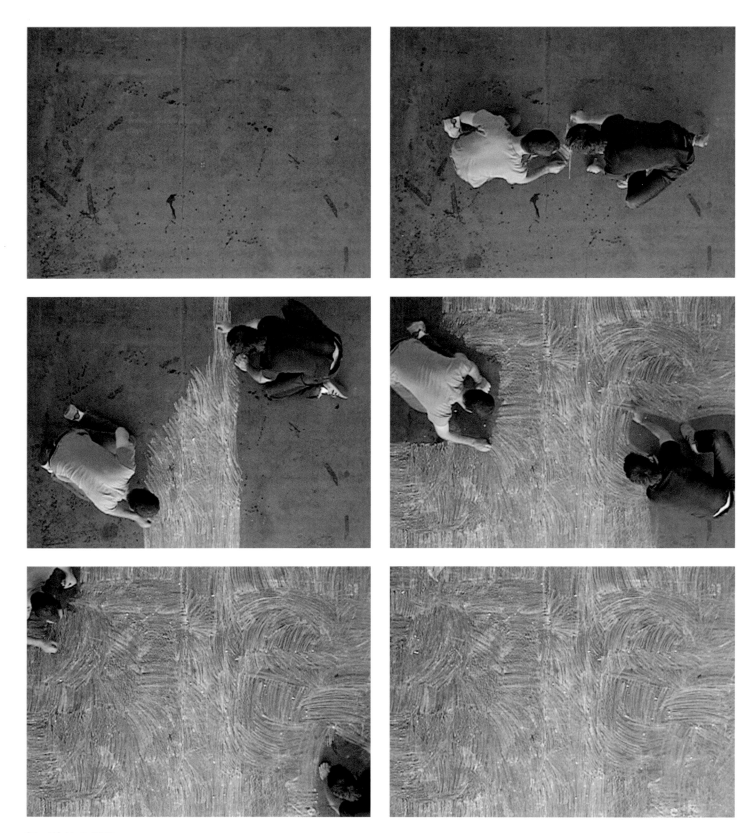

{fig. 17} *Mark*, 2002
Single-channel video, 34:00 min.

And at that point I said, 'Well, what's the point? All of the ideas are for Type A. All of the fun is with Type A. And the work is much better with Type A.'"[14]

Like *Mark, Stand* deals with measurement systems, this time comparing weight and height. The diptych *Stand (height)* further explores the relationships between the two constituent parts of the collective, again using a reductive formal vocabulary to interrogate the relationship between equivalence and/or balance and difference and/or imbalance {fig. 19, pp. 120–21}. Like many of the preceding works, this one hearkens back to performance art and video of the seventies, such as Marina Abramovic and Ulay's *Relation Work* project (1976–79), which set two performers in relation to each other in terms of breathing, movement, time, and balance {fig. 20}.

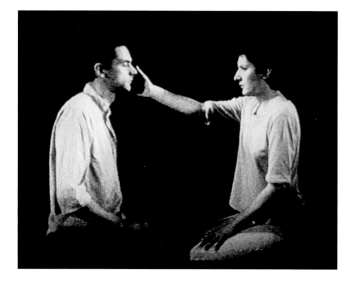

{fig. 20} Marina Abramovic / Ulay, *Light/Dark*, 1977 Courtesy of the artist and Sean Kelly Gallery, New York

In *Stand*, shot against the backdrop of the seashore on New York's Fire Island, Bordwin stands in a hole to approximate the height of Ames's adjacent physical frame. In the second photo Bordwin stands flat on the sand while Ames ascends a square sand platform to eradicate their height difference. Likewise, in the triptych *Stand (weight)* {fig. 21, pp. 34–35}, Type A investigates the literal disparity between their weights using a piece of plywood perched on top of a log, like a makeshift seesaw. Each stands on one end, revealing Ames as the lighter of the two, with Bordwin weighing him down with his tall, lanky frame. In the middle of the triptych, they demonstrate equivalency by giving Ames seven bricks to hold. In the final photograph, Ames increases his brick load substantially, in order to outweigh Bordwin and force him to rise into the air.

Push, a series that incorporates graphite on paper and crayon on paper drawings and chromogenic prints, was the first project Type A did after moving into their new studio in Chelsea. It further explored the notion of collaborative territory first considered in *Mark*.[15] Here they took advantage of their large space by placing pieces of paper which measured either sixty by one hundred twenty inches or eighty by one hundred fifty inches on the floor. Standing on top of the paper, Ames and Bordwin took turns shoving each other and then documenting the pusher's step or the pushee's landing in various combinations that were numbered consecutively {figs. 22, 23, 24}. The result is the creation of an environmentally

14| Bordwin, in an interview with the author, September 3, 2008.
15| The most comprehensive discussion of the *Push* project is Reena Jana's "Push and Pull" (see note 9).

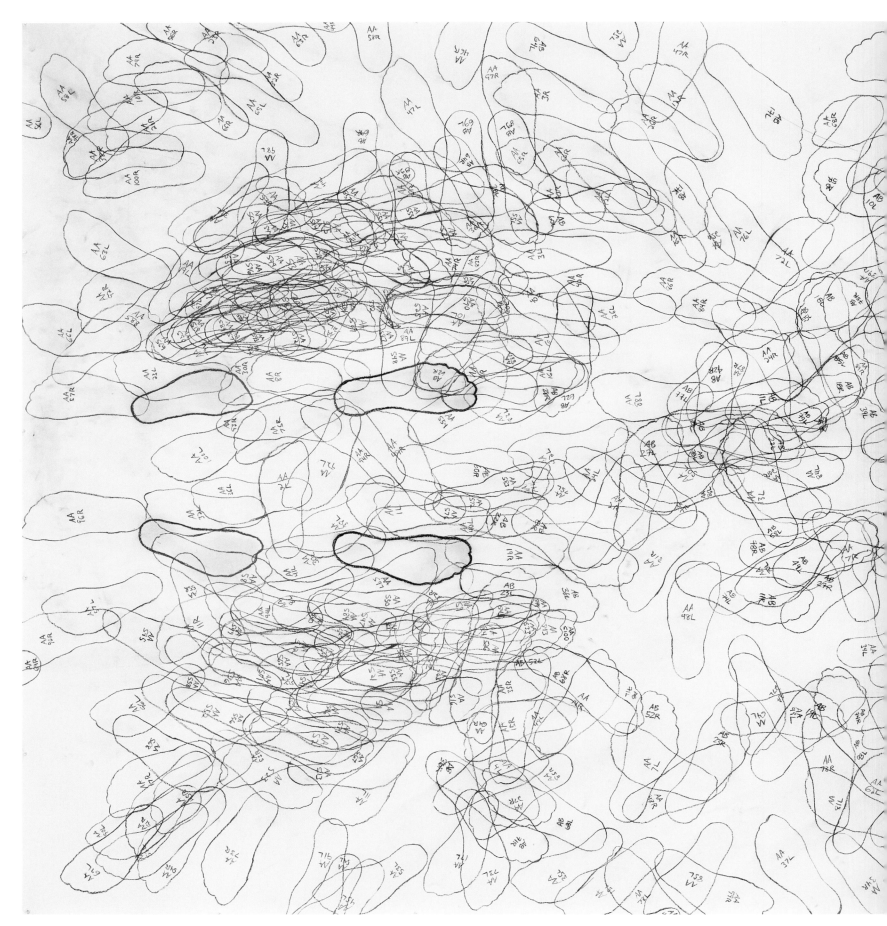

{fig. 22} *Push AA <—> AB / 200 (c)*, 2004
Crayon on paper, 80 x 149½ in. Collection of the Indianapolis Museum of Art. Purchased with funds provided by Mark Demerly, Mark and Jean Easter, Kent Hawryluk, Susie Jacobs, Pat and James LaCrosse, Ron Reeve, Anna and James White, Trent Spence, George and Jan Rubin, and Mary Wicker, 2009.55

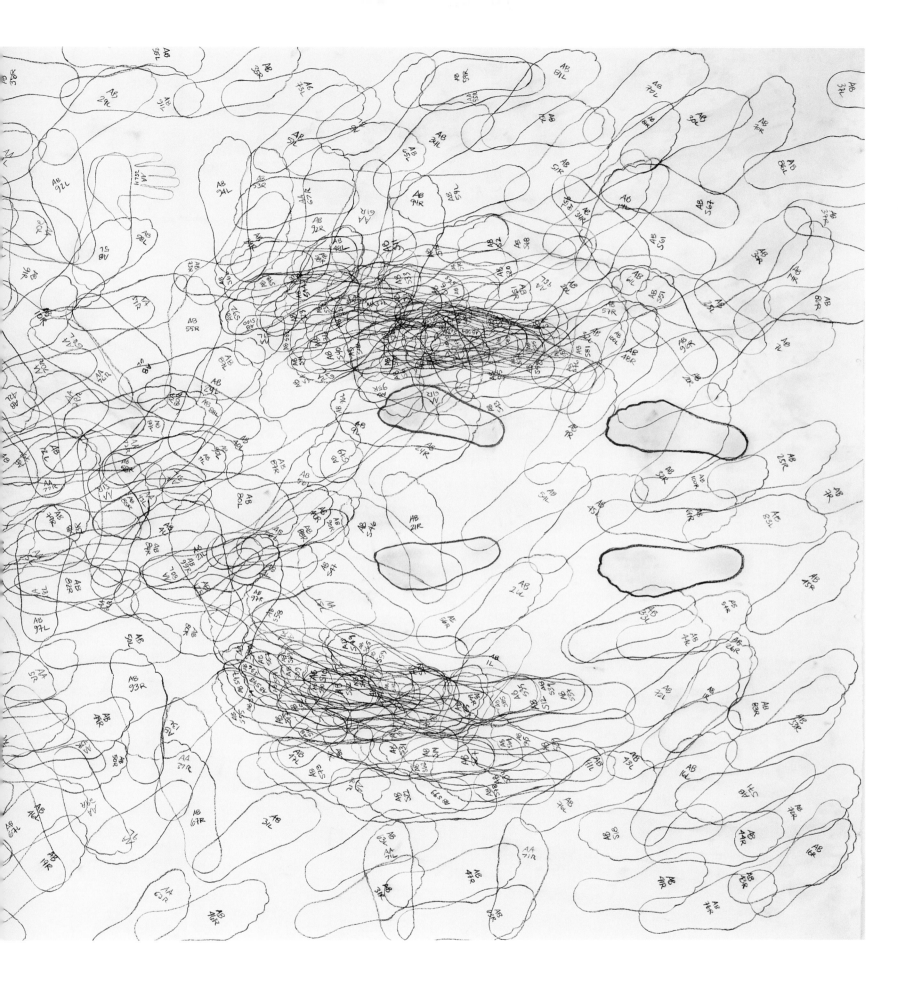

scaled drawing made from the documented movements of the artists in real time and space. Type A explains:

> *The pusher's step, the pushee's landing or some combination thereof is outlined and systematically numbered in sequence. The result is part dance chart, part Twister, part motion study. The paper becomes a wrestling ring or battleground, the evidence of each push documented with footprints and smudges. The drawings exist as detailed evidence, a brief history of itself that can be used to reconstruct the entire process after the fact by carefully examining and sequencing each footprint.*[16]

While the wrestling match in *Dance* had been an unusual game of Twister, *Push* similarly conceived the ground or work space as a battleground, but allowed for a significant strategic change. Rather than simply having the same pusher relentlessly pushing the victim, refusing the kind of back and forth that would be required in an actual dance, in this piece Type A allowed for reciprocity, taking turns using an aggressive gesture as a means to collaboratively produce the work. Various writers have acknowledged the historical importance of Action Painting for this series, particularly with regard to the decision to occupy the space of the drawing on the floor and to move across it making marks that index the pushes and landings.[17] Andy Warhol's instructional Dance Step drawings and paintings (1962), which he copied from dance books published by the Dance Guild in 1956, also present an important comparison with *Push*. Warhol copied a preexisting diagram that others were meant to reenact precisely and mechanically {fig. 25}; Ames and Bordwin used the traces of their own bodies to produce improvisational marks, work that had no preconceived outcome. But because Type A systematically numbered and recorded every push and landing, they could reenact the same movements by following the order in which they occurred. The photographs that they took of their push dance, which are indebted to nineteenth-century British photographer Eadweard Muybridge and twentieth-century modern dance, gracefully demonstrate how the same actions translated via different media result in different formal variations {fig. 26}. Using a black backdrop and short interval strobes, the camera captured the isolated movements, responses to being pushed through time and space.

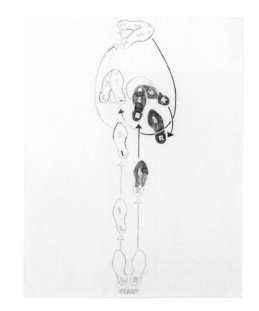

{fig. 25} Andy Warhol, *Dance Steps*, signed and dated "Andy Warhol 62" (on the reverse), drawn in 1962
Pencil on paper, 40 x 30 in.
© 2010 Andy Warhol Foundation for the Visual Arts / Artists Rights Society (ARS), New York

16| Artist statement, *Push*, www.typea.us.
17| See, for example, Molon 2006 (see note 6), p. 16. In the *Village Voice* art listings of April 1, 2003, Kim Levin described "arcane references [in Type A's work] stretching from Pollock to [Roman] Polanski." Reena Jana, in "Push and Pull" (see note 9) compares the paper proportions used in *Push* to those of a "Jackson Pollock canvas." The documentary photos of Type A's process of creating the drawings are undeniably reminiscent of those that Hans Namuth took of Pollock making his paintings.

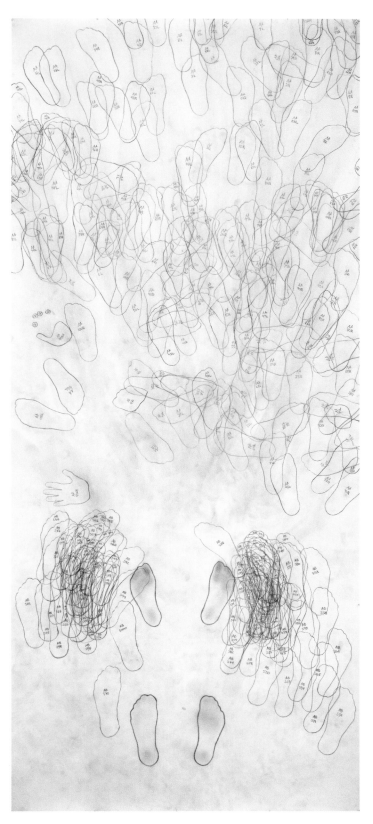

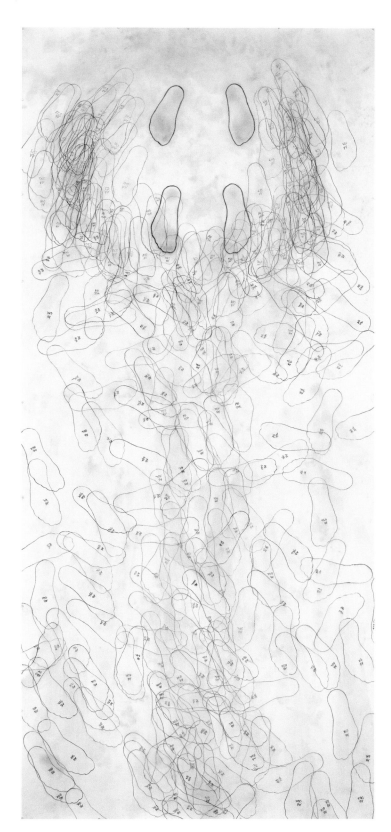

{fig. 23} *Push AA <— AB / 100,* 2004
Graphite on paper, 60 x 140 in.

{fig. 24} *Push AA —> AB / 100,* 2004
Graphite on paper, 60 x 140 in.

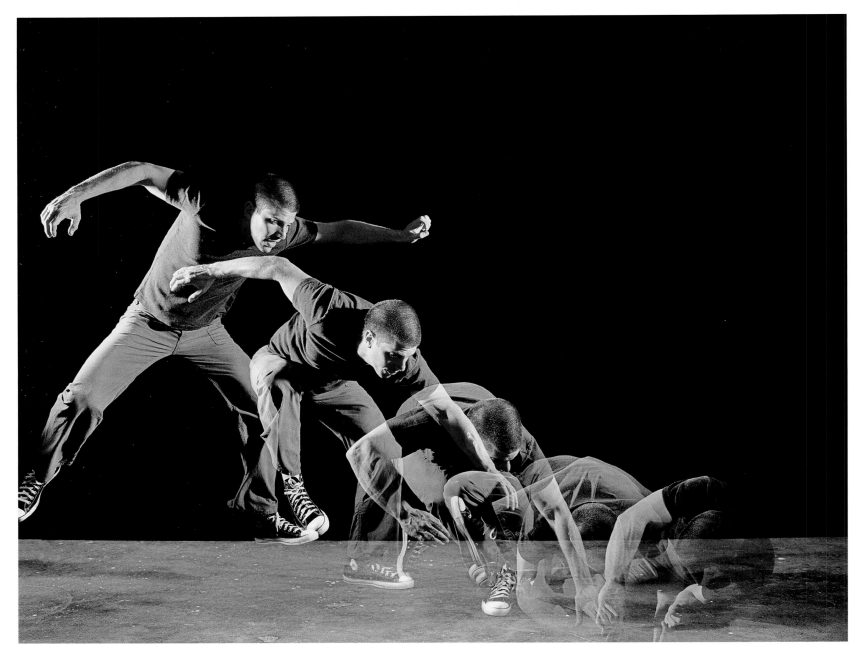

{fig. 26} *Untitled (AA<—>AB/5-1),*
from the *Push* series, 2004
Chromogenic prints,
20 x 24 in. (each)
Collection of the Indianapolis
Museum of Art. Purchased with
funds provided by Howard and
Anita Harris and the Anita Harris
Birthday Fund, 2009.56a–b

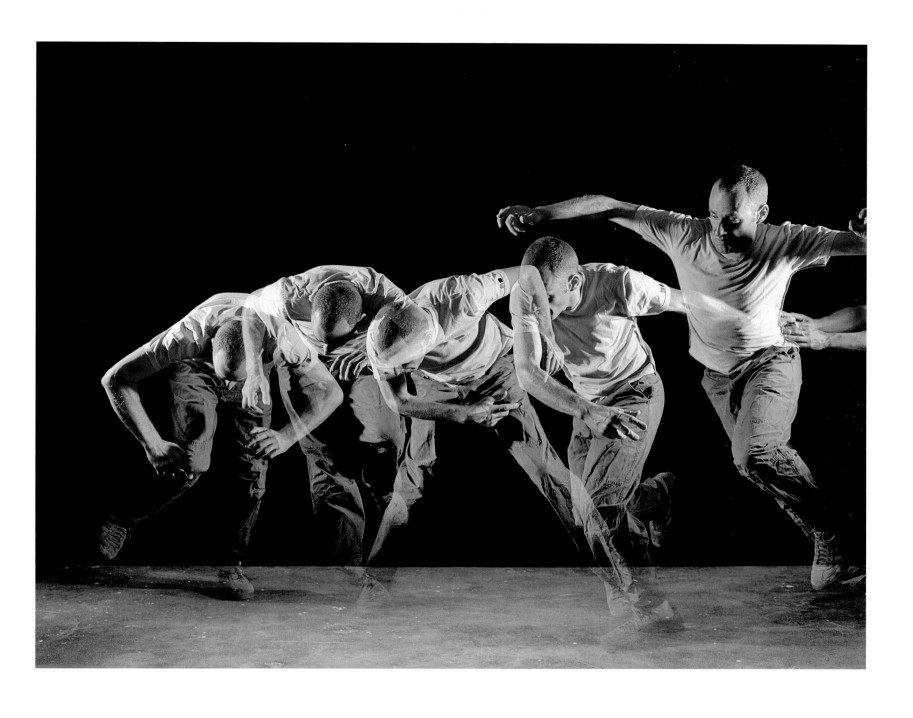

In 2006, curator Allison Kemmerer invited Type A to participate in a residency at the Addison Gallery of American Art, Phillips Academy, in Andover, Massachusetts. While there, Type A made an overt leap in their practice, moving beyond their exclusive partnership to engage others who would perform their challenges. This was the first time Type A collaborated with an art institution on a project with a common purpose. Kemmerer asked the artists to develop a project that somehow incorporated the student body at Phillips Academy. Walking around the campus of the elite New England prep school, Type A zeroed in on the two spirit teams, SLAM and the Blue Key Society, which featured uniforms with giant As on the front. Ames and Bordwin worked with the teams to develop a single-channel video featuring the all-girl uniformed SLAM team {fig. 27} and the Blue Key Society {fig. 28}, a more peppy, less structured group of boys and girls decked out in necklaces, boots, sneakers, and flip-flops. The video of the two groups builds on the dance-like *Push* project, which focused on the tension between control and release, choreography and improvisation. The juxtaposition of two teams in *Cheer* emphasizes the distinct character of the groups: one rigid and almost militaristic, the other free-form and festive. While Type A shot the SLAM team straight on and did not appear in the video at all, they made a subtle appearance in the second part. They watch the Blue Key Society from the bottom of the bleachers, their backs turned to the viewers of the video, as the group cheers in front of them. Moving themselves from the primary role of performers into the dual roles of performers and spectators, they occupy an expanded territory, suggesting the new possibility that the spectator could break through the frame and participate in their work. Previously, Type A never had had a real audience for their performances; now they were the object of direct adulation and the typical performer-audience relationship was reversed, allowing for a new kind of reciprocity to occur. The performers and spectators could function as both simultaneously. The Addison residency allowed Type A to move beyond the confines of their established two-person collaborative to enlist the participation of a broader range of people, both male and female. While the project became a platform for investigating Type A's interest in teams and public collaboration, the artists admitted that those projects "basically took other people and involved them, but made them look like us."[18] They were still not ready to release their control over the subject or final product: "I don't think it was even a question of 'Are we going to let [our way of making work] go

[18] Ames 2008 (see note 1).

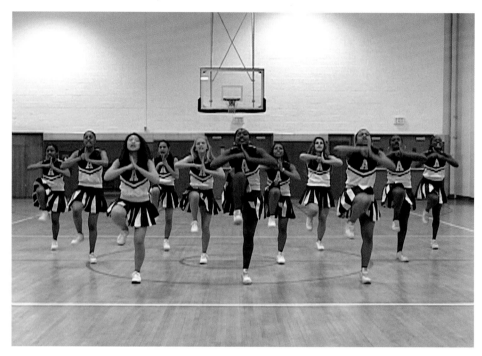

{figs. 27 & 28} *Cheer*, 2006
Single-channel video, 5:14 min.

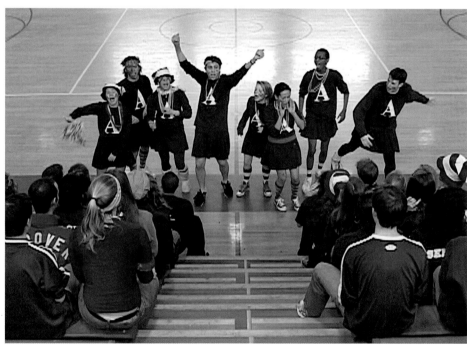

and have the art or experience take on its own form?' It just wasn't part of the equation."[19]

Since the early nineties, a growing number of curators, scholars, and artists have been writing about and developing socially based aesthetic practices that pose a stark alternative to what, since the late sixties, has been referred to as "public art," despite the fact that this work rarely has engaged the public specifically. Situated in the public sphere, engaging a range of diverse audiences, the new experimental work has been variously described as "new genre public art," "relational aesthetics," "dialogical aesthetics," "collectivism," and "participatory art."[20] As artist and activist Suzanne Lacy explained in 1994, "new genre public art" can be distinguished from public art birthed by programs like the National Endowment for the Art's Art in Public Places because it places the "relationship between artist and audience" at the center of the work. This work "activates the viewer—creating a participant, even a collaborator."[21] In her essay "An Unfashionable Audience," Mary Jane Jacobs—one of the first curators to work in this fashion—advocated for a new kind of public art practice where the audience's relationship with the art work was "considered as the goal at the center of art production, at the point of conception."[22] She went on to suggest that to reach this audience most effectively, one must move beyond the museum's traditional educational outreach programs, which had failed because of their inability to develop reciprocal relationships of "exchange and mutual respect."[23] Museums, therefore, might not be "the most appropriate starting point for larger, new audiences for contemporary art," and that by "departing from the institution, new meaningful ways to engage a wider audience for contemporary art can be greatly multiplied."[24] Fifteen years after Jacobs wrote that essay, I find myself in the contradictory position of both acknowledging the import of moving outside the museum and into "non-art-world venues" and asserting the necessity for museums to reinsert themselves into this history and to become integrally connected with their communities and cities, to be catalysts for social change, collaboration, and activism. If museum administrators and curators are willing to be flexible and creative, they have the opportunity, especially in times of limited funding, to support experimental, critically engaged participatory avant-garde projects that have the potential of creating meaningful exchanges with their varied publics. New social networking platforms available through the Internet also present

19| Ibid.
20| See for example: Suzanne Lacy, ed., *Mapping the Terrain: New Genre Public Art* (Seattle, 1995); Nicolas Bourriaud, *Relational Aesthetics* (Paris, 2002); Grant H. Kester, *Conversation Pieces: Community + Communication in Modern Art* (Berkeley and Los Angeles, 2004); Claire Bishop, ed., *Participation,*

Documents of Contemporary Art series (London and Cambridge, Mass, 2006); Rudolf Frieling, *The Art of Participation: 1950 to Now* (San Francisco, New York, and London, 2008).
21| Lacy 1994 (see note 20), p. 37.
22| "An Unfashionable Audience," in Lacy 1994 (see note 20), p. 50.

23| Ibid., p. 51.
24| Ibid., p. 52.
25| Bourriaud 2002 (see note 20), p. 13.
26| Ibid.
27| Ibid., pp. 14–15.
28| Substantial information about the 100 Acres projects, including the inaugural commissions, can be found on the IMA's Web site: www.imamuseum.org.

29| The origins of experiential education date back to writings of psychologist and philosopher John Dewey. Several of his texts related to nature, art, and education focus on experience as the centerpiece. See, for example: John Dewey, *Experience and Nature*, Lectures upon the Paul Carus Foundation, First series, 1925; John Dewey, *Art*

as Experience (New York, 1934); and John Dewey, *Experience and Education*, The Kappa Delta Pi lecture series, no. 10 (New York, 1938). The Association for Experiential Education defines experiential education "as a philosophy and methodology in which educators purposefully engage with learners in direct experience and focused

museums with tremendous opportunities for expanding their interactive audience relationships at a time when traditional outreach is coming up short. As Nicolas Bourriaud asked in his now landmark text *Relational Aesthetics,* what if we could use art to help us learn "to inhabit the world in a better way, instead of trying to construct it based on a preconceived idea of historical evolution?"[25] According to Bourriaud, "the role of artworks is no longer to form imaginary and utopian realities, but actually be ways of living and models of action within the existing real, whatever the scale chosen by the artist."[26] Relational art, therefore, is a "social interstice," "an arena of exchange" that engages human interactions in particular social contexts, rather than in a "private, symbolic space." Art then is no longer "a space to be walked through" but "a period of time to be lived through, like an opening to unlimited discussion."[27]

Intrigued with the possibilities for commissioned art projects to function as opportunities for socially and aesthetically based exchange and discourse, I began to develop a new premise for a museum art park when I arrived at the IMA in 2002. Instead of buying preexisting permanent sculptures to place throughout the generous one-hundred-acre park, I settled on a model of impermanence and site-responsiveness. The idea was to invite international artists at all stages of their careers to develop temporarily sited works in response to the specific conditions of the park.[28] The landscape would become a constantly changing space for experimentation.

In spring 2007, Type A visited the IMA's developing park so that they could produce a proposal for one of the eight inaugural commissions that would premiere there in June 2010. After coming back to the museum several times, and studying the site and the context, Type A shared with me an unconventional and unprecedented idea that had grown out of their long-standing investigation into the aesthetics of collaboration. As in most of their preceding work, Type A turned to the world of popular culture for inspiration, and in this case they initially looked not to film, art history, or sports, but to the experiential education and adventure industries, specifically with regard to the theory and practice of team building.[29] This move seemed logical, given their tendency to take preexisting frameworks or territories for the purpose of conducting particular aesthetic experiments. It also made sense because one of the primary goals of team building is to develop effective collaboration.

reflection in order to increase knowledge, develop skills and clarify values." Association for Experiential Education, "What is Experiential Education?" (no date) http://www.aee.org/about/whatIsEE (accessed November 13, 2009).

Ames and Bordwin explained that they hoped to become trained facilitators at a respected experiential education program and then return to the IMA over the course of a year or more to "team-build" the staff who would be working on developing the park.[30] I presented the concept to the IMA's senior management, to the museum's director, and to the director of human resources, all of whom gave staffers the freedom to partake in the project if they agreed to do so. Participants commited to five day-long retreats over the course of a year. We chose staffers from all divisions within the institution: buildings, finance, security, horticulture, education, grounds, design and installation, public affairs, curatorial, conservation, retail, and special events. Type A decided to work on a relational aesthetic project with a specified public: a microcosm of Indianapolis, with a range of religious, sexual, political, and philosophical orientations.

The entire project—from the moment Type A attended High 5 Adventure Learning Center in Vermont, to their multiple visits for team-building the IMA staff, to blog and Flickr postings and photographic and video documentation—was an extended experiential performance in real time. How would the team-building process, the wide-ranging bonding activities, games, and challenges involving group dynamics, relate to the final work Type A would install in the park? How would the experiences and interactions affect the relationships between these people within the institution and in relation to the final project itself? In part because of their experiences with the spirit teams at Phillips Academy, Type A wanted to challenge their own relationship to collaboration, this time partnering with the museum and allowing their own insular practice to expand to a larger public. This meta-project became a small experiment within a large institution, one meant to build stronger teams and expand the traditional understanding of artistic and museological collaboration, so that a defined public, in this case the IMA team, could work closely with Type A to develop the concept for the final object that would be installed in the park. It became apparent that this community, largely untrained with regard to aesthetics, would have the chance to work closely with the artists and curator, conversing about the creative ideas at hand and how they should be implemented. It allowed them a way to understand how the project was conceived and developed over its lifespan, something rarely disclosed to the public.

The prominence of humor and absurdity in much of Type A's work begs the question as to whether or not they intended to take the team-building process

30| Type A trained with two facilitators, Jim Grout and Jen Stanchfield, both of whom have published about team building. See, for example: Jim Grout and Nicki Hall, *The High 5 Guide: Challenge Course Operating Procedures for the Thinking Practitioner* (Dubuque, Iowa, 2007) and Jennifer Stanchfield, *Tips & Tools: The Art of Experiential*

Group Facilitation (Oklahoma City, 2007).
31| Bordwin, in Type A interview with the author, 2008 (see note 1).

seriously, or if they were approaching it from a critical or even ironic perspective. Type A began their team-building training at High 5 with a certain degree of uncertainty and skepticism. As self-professed control freaks, they did not like the idea of anyone telling them what to do, but they were intrigued by the prospect of doing some of the extreme physical activities. They explained:

We were concerned that it could get preachy. We wanted to have fun . . . we were told in conversations with several people . . . that [facilitation in experiential education] . . . offers potentially life-changing experiences. . . . And we thought, 'OK, if you say so.' But we were not sold, and . . . the whole point of adventure experiential ed is that it's not words, it's not sitting there and listening to people, it's doing. And until we did it, we had no idea what it was going to be like.[31]

Ames acknowledged that, very early in the training process, they both realized that it would not do them any good to fight the experience and that they needed to commit to it and see what would happen {figs. 29, 30}. Over the course of their

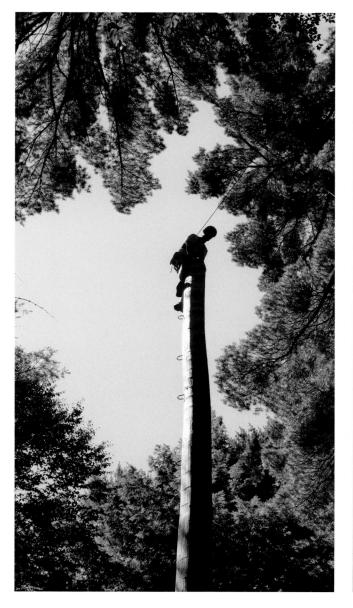 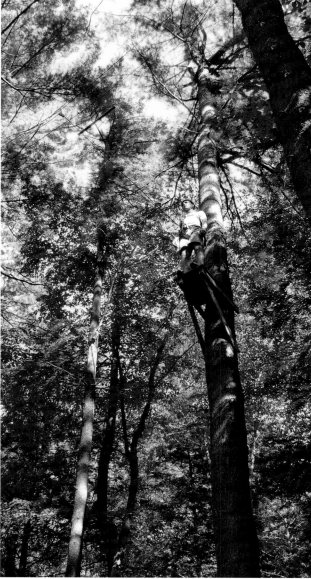

From left to right:
{fig. 29} Adam Ames nearing the top of the Pamper Pole, High 5 Adventure Learning Center, Vermont, July 2007
{fig. 30} Andrew Bordwin perched on the Pamper Platform, High 5 Adventure Learning Center, Vermont, July 2007

training, they began to "be moved by it," wondering how they could ever convey their experiences to anyone who had not been there. Bordwin explained: "We both had experiences . . . which were very powerful and very genuine. . . . At the time we said it was a life-changing experience and I stand by that, and I think that the reason why the people who do it are so committed to it is because . . . once you experience that . . . it's sort of impossible not to . . . remain connected to it."[32]

When Type A came to the IMA, they commited to finding out what would happen if they used the structure of team building as an aesthetic medium. They worked to determine how our newly formed group could improve cooperation, communication, problem solving and leadership skills, and how these new skills would relate to the collaborative process of determining Type A's final installation for the park. Once our meetings began, we interspersed various games and initiatives with long conversations that addressed the purpose of 100 Acres and questioned the role of the *Team Building* project {figs. 31–34}. We agreed that the projects needed to relate specifically to the site and should somehow take into consideration the relationships between art and nature. No one knew how the artwork was going to turn out.

The challenges and tensions inherent in this collaboration between the artists and their public were evident from the start. Type A's previous analyses of their own collaboration, as seen in the *Twins Project*, *Mark*, *Push*, and *Cheer*, were instructive for the leap into their experimentation with the IMA group. There was a need to establish clear differences between each of the respective identities. The team and the artists had different roles to play, and it was evident that both sides understood those constraints. The tension between the two so-called collaborators also revealed the blurring of separate, multifaceted identities that took place over time when they worked together. There was the space of the museum when Type A was not present; Type A's practice in their New York studio without the IMA team; and the space that the team formed with Type A when they visited the IMA. All of this pointed to the artists' earlier exploration of private and shared territories, which would become an important basis of this project.

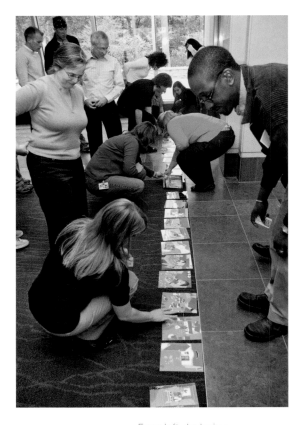

From left clockwise:
{fig. 31} IMA staffers doing the Zoom Initiative in the IMA's special events pavilion, April 28, 2008
{fig. 32} Ames and Bordwin with IMA team in conversation in the contemporary galleries, July 14, 2008
{fig. 33} IMA team choosing museum postcards to trigger associative discussion at the Garden Terrace, July 14, 2008
{fig. 34} IMA team discussing juggle drawings with Type A on the museum grounds, July 14, 2008

32| Ibid.

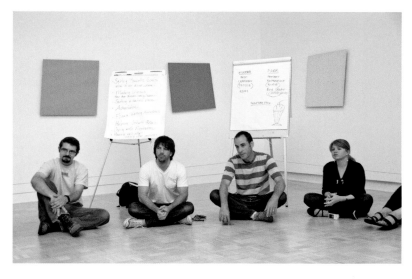

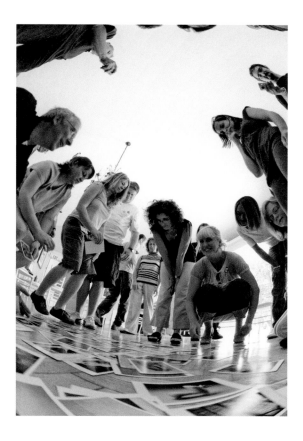

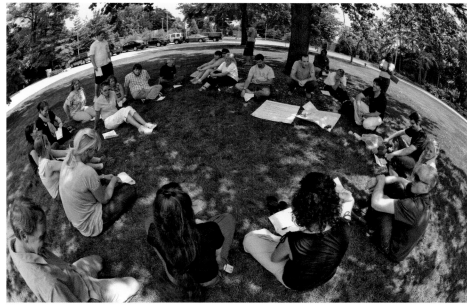

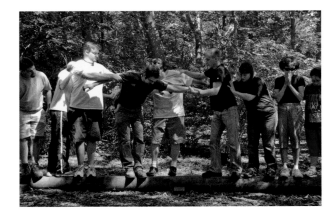

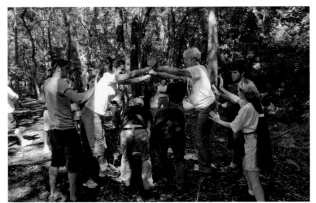

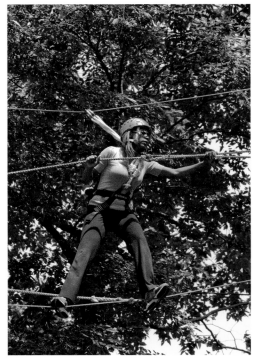

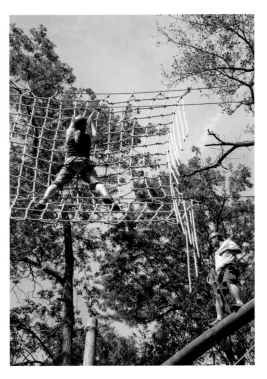

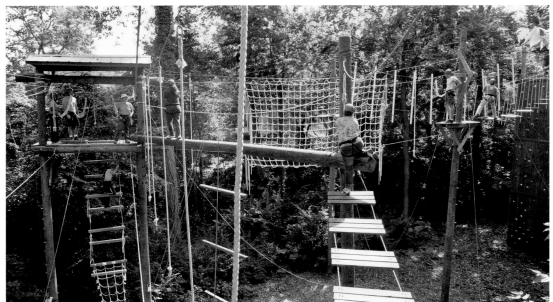

From left clockwise:
{fig. 38} IMA team members on the low course at Butler University, Indianapolis
{fig. 39} IMA team members working together on the low course at Butler University, Indianapolis
{fig. 40} Kimberly Coleman (Human Resources) on the high course, Butler University
{fig. 41} Jyl Kuczynski (Development) on the high course with Ames in the background looking on
{fig. 42} The high course at Butler University, Indianapolis

In 1934, the theorist, philosopher, and educator John Dewey, one of the founders of experiential education, wrote in his book *Art as Experience* that "Equilibrium comes about not mechanically and inertly, but out of, and because of, tension."[33] Productive, active tension is exactly what enabled Type A to move beyond their comfortable established relationship to become a newly defined entity with the IMA team. The goal was to come into alignment around the final product or "residue" of the *Team Building* project, to achieve a kind of balance not unlike what the artists had explored literally in *Stand.* But Type A had preconceived notions about certain aspects of the project—in this case, the sculpture for the park. Even before they convened their first meeting with the 100 Acres team in April 2008, they had begun to think about how or if their year-long experiences at High 5 and the IMA could be resolved in physical form.

Type A introduced the preliminary concept for the sculpture as a type of institutional critique. Could they build a climbing tower in the park, but have the

group actually use it first? Was there a way "to have the institution become the piece?" Their ideas coalesced into a proposal for a forty-foot-high tower suspended from poles with handgrips made from the cast hands of all the team participants {figs. 35–37}. It would create an unexpected juxtaposition, a metaphor for the

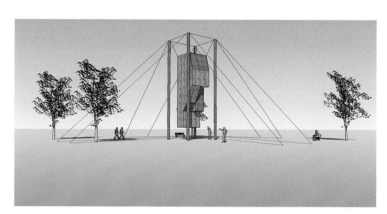

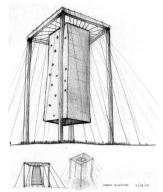

role of art in the twenty-first century. Suspended high in the air, with no way to scale it, the Tower became an absurd, unreachable object, one meant to be used, but made inaccessible and useless through its placement.

After many months exploring various initiatives on the IMA campus, the team finally had the chance to work on Butler University's ropes course in late September 2008. While the low elements focused on group cooperation {figs. 38, 39}, the high elements centered on individual challenge {figs. 40–42}. This is where I found

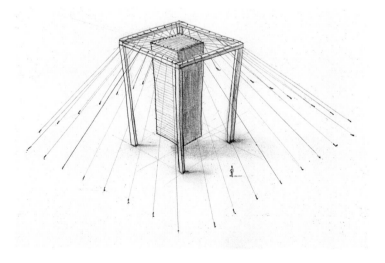

33| Dewey 1934 (see note 29), p. 14.

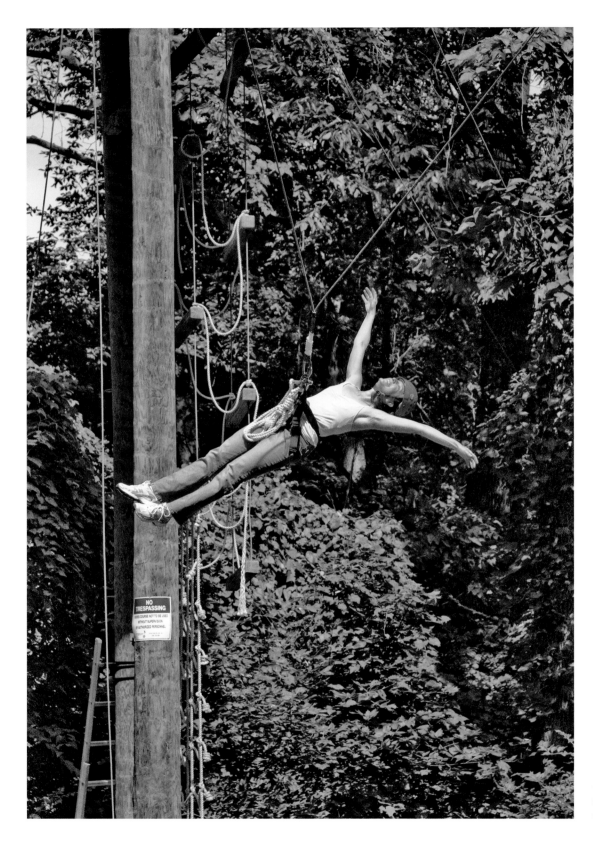

{fig. 43} Lisa Freiman (Curatorial) swinging through the air, dismounting from the high course

myself in that precarious position mentioned previously, where I never would have been had it not been for my collaboration with Type A. Forty feet up in the air and fearing for my life, I took that next step with Ames's encouragement, and I made it all the way to the end of the course. There I faced a precipice from which I needed to leap in order to get down to the ground. I sat on the edge of the platform and looked down at Ames and Bordwin, who were awaiting my descent. As I tried to gather my resources, I took a deep breath and jumped, flying through the air {fig. 43}.

The personal struggle that I faced on the ropes course, and which each of the team members encountered at different times over the course of the *Team Building* project, was instructive. Through their carefully choreographed, experientially based meetings, Type A taught us that a balance of success and failure is essential. Simultaneously, Ames and Bordwin began to address a new challenge: They began to recognize that they needed to square their egocentric desires with those of the expanded group. The traditionally separate creative space between the artist and the public began to blur, just as the circular traces of Ames and Bordwin's bodies had done in *Mark*. Gradually, individual team members as well as consulting facilitators Jim Grout and Jen Stanchfield began to speak out about their dissatisfaction with the Tower. Why would the final installation be a tower at all when neither Type A nor the IMA team had yet scaled one? How could that specific form represent the group's experience, especially after the intense connections made in our repeated meetings and on the ropes course? In the face of the team-building experience, which focused on the blurring of art and everyday life, why would we want a critical symbol of art that pointed to its uselessness?

With increasing pressure being mounted from all sides, Type A acknowledged that the Tower began to feel unrelated to their work with the IMA team. They built part of one visit around a discussion of the sculpture, allowing for the possibility that the team's input might influence the design of the final work. Although the discussions were without resolution, they inspired Type A to reconsider the sculpture's design. Bordwin acknowledged that "there's something interesting when you set up . . . an engagement of some sort, whether it's competitive or not, and there's a balance that results on its own. It results naturally without any choreography." He continued: "You make a piece; there's that arc: the idea, conception,

and then progress, and then that tipping point, that sort of peak, where you stop telling the piece what it is. It starts telling you what it is. And if you're prepared to listen at that juncture, then the piece can have a really good chance of being successful"[34]

Type A subsequently developed a series of sketches {figs. 44, 45} that suggested a new formal direction for the sculpture that was more closely synchronized with their IMA team experience:

A clock of sorts, A time/place piece for the group
A sundial gauged for the moment of significance.
A place that is a pure reflection of the present
A way to connect the trees using the group's decision, and
a way for the trees to participate in the piece.
Every moment is significant and offers a place for
contemplation. But there is, built into the piece, an
opportunity for the group to come together in a place and
time that is significant to them, annually.
The creation of a third thing from two: 1+1=3.
Eternity. A collaboration with the earth and its movement
around the sun
The result—a place defined by shadows—is as intangible,
and potentially significant, as the group's work?[35]

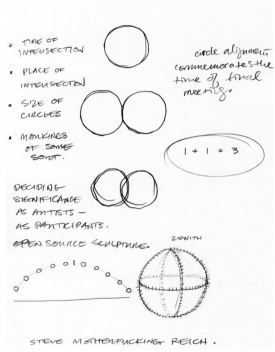

{fig. 44} Notes and drawings from Andrew Bordwin's sketchbook showing circle alignment, October 2008
{fig. 45} Sketch of *Team Building (Align)*, final proposed sculpture for IMA *Team Building* project, October 29, 2008
Graphite and colored pencil on paper, 14 x 17 in.

The final installation, *Team Building (Align)*, consists of two thirty-foot-wide metal rings suspended from telephone poles with guy-wires, one at fifteen feet and the other at twenty-five feet, and oriented so that their two shadows become one during the annual summer solstice {fig. 46, p. 66}. *Team Building (Align)* resulted from an unexpected collaborative aesthetic process that joined two separate entities: a large cultural institution and a small artistic duo—not in opposition or critique— but in a sincere partnership meant to test the possibility of a formally challenging, collaboratively produced project. The circles of *Team Building (Align)* became a metaphor for the tensions between individuality and community. The forms emerged from the physical interaction of participants throughout the year of team-building exercises. We started every initiative by circling up, and every one

34| Bordwin 2008 (see note 1).
35| Page from Type A's sketchbook, October 25, 2008.

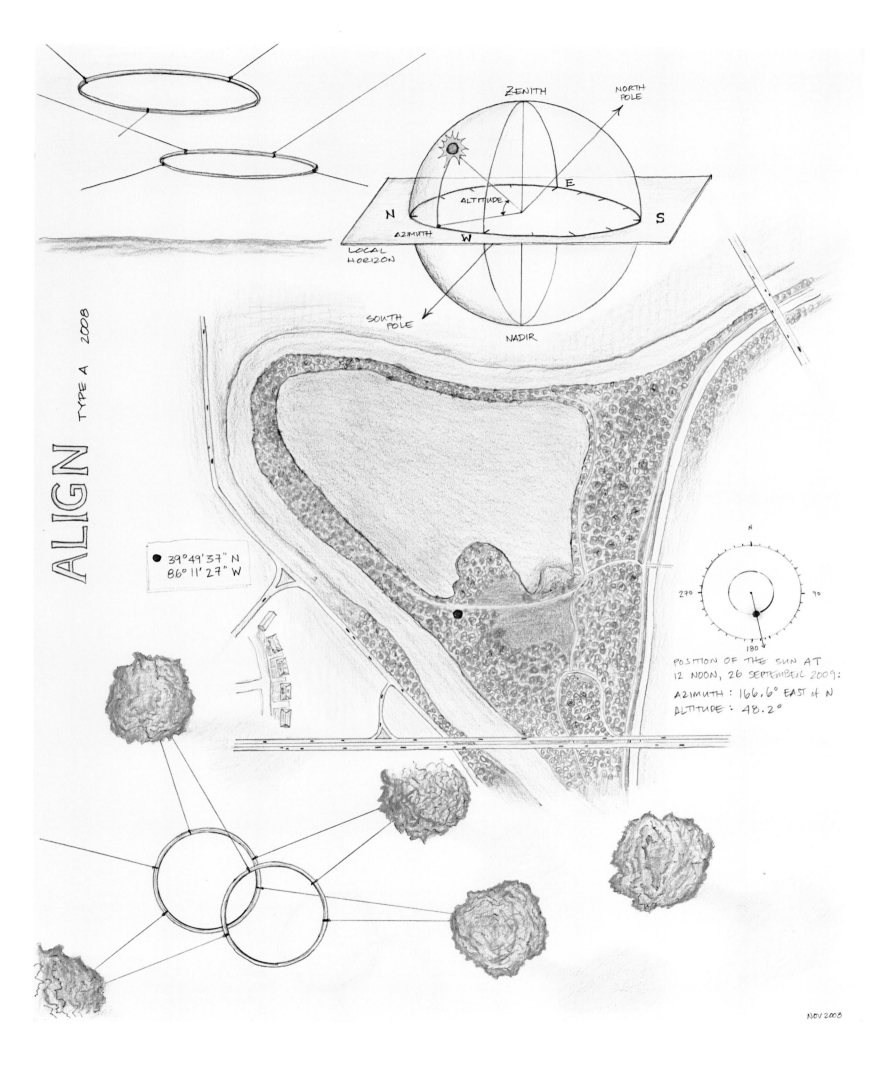

ALIGN TYPE A 2008

ZENITH

NORTH POLE

LOCAL HORIZON

ALTITUDE

AZIMUTH

N W S E

SOUTH POLE

NADIR

● 39°49'37" N
 86°11'27" W

N

270 90

180

POSITION OF THE SUN AT
12 NOON, 26 SEPTEMBER 2009:

AZIMUTH: 166.6° EAST OF N
ALTITUDE: 48.2°

NOV 2008

encircled talking about what we had learned {see fig. 32}. The form was an unspoken presence at first, and then became an acknowledged part of our time together.

The birth of the new sculptural form pointed to what Bourriaud had argued a decade earlier:

[F]orm only assumes its texture (and only acquires a real existence) when it introduces human interactions. The form of an artwork issues from a negotiation with the intelligible, which is bequeathed to us. Through it, the artist embarks on a dialogue. The artistic practice thus resides in the invention of relations between consciousness. Each particular artwork is a proposal to live in a shared world, and the work of every artist is a bundle of relations with the world, giving rise to other relations, and so on and so forth, ad infinitum.[36]

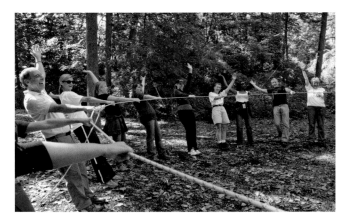
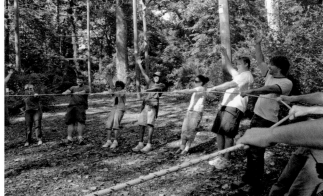

{fig. 47} IMA staff and Type A doing the Yurt Circle initiative at Butler University
{fig. 48} Type A and team with Indianapolis community members at 100 Acres groundbreaking, September 2008

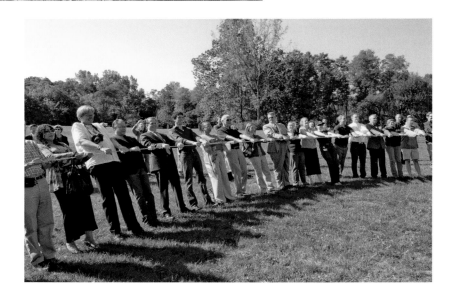

One of the low-course initiatives, the Yurt Circle, required the team to form a circle around a rope, to pick it up simultaneously, and balance each other's body weight by leaning back away from it {fig. 47}. The main idea was to work together to achieve overall balance so that the integrity of the circle would hold. We conducted the Yurt Circle initiative again at the 100 Acres groundbreaking in September 2008, inviting IMA donors, members, the general public, reporters, and TV newscasters to unify as one community {fig. 48}.

The literal form of *Team Building (Align)*'s suspended rings evolved from the materials used in the Bull Ring initiative. In this activity, two groups each hold onto a set of long strings attached to a metal ring in a sunburst pattern {fig. 49}. The object of the game is to work together to transfer a tennis ball sitting on one of the rings to the empty ring suspended by the other team without dropping it. In the new sculpture, Type A magnified and monumentalized the small metal rings and strings {fig. 50}. Rather than being held up by people, the huge rings would be attached by guy-wires to telephone poles {fig. 51}. Type A needed to determine the exact placement of the rings so that over the course of a year, as the earth rotated around the sun, the rings' separate shadows would move gradually into alignment to form one circle. To calculate these measurements, Type A worked with Brian Murphy, an astronomy professor at Butler University's Holcomb Observatory. They reviewed Type A's preliminary sketches and made new diagrams demonstrating how the rings could align in 100 Acres either during the winter or summer solstice {fig. 52}. Type A subsequently presented these possibilities to the IMA team, asking for feedback about the overall revision, and about the size of the rings and the preferred date of alignment. The group was overwhelmingly pleased, if surprised, that the artists would relinquish their initial idea for the Tower in reponse to the group's ongoing critique. They agreed that the rings should approximate the size of the group when it came together in a circle. They also wanted the alignment to happen during summer solstice, when the park would open initially, so that a broader public, beyond their literal circle, could experience what happened when the earth and sun collaborated.

Dewey believed that we only have "an experience when the material experienced runs its course to fulfillment."[37] He saw experience as process and movement, a flow "from something to something." Over the course of the past two years, the *Team Building* project had moments of pause that helped define the final product.

36| Bourriaud 2002 (see note 20),
p. 22.
37| Dewey 1934 (see note 29), p. 35.

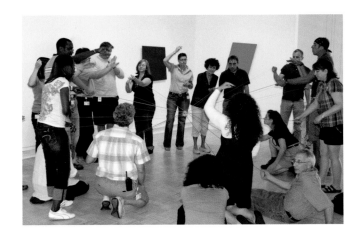

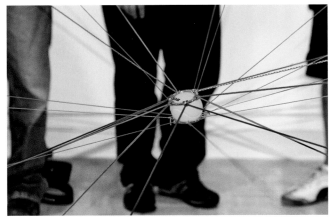

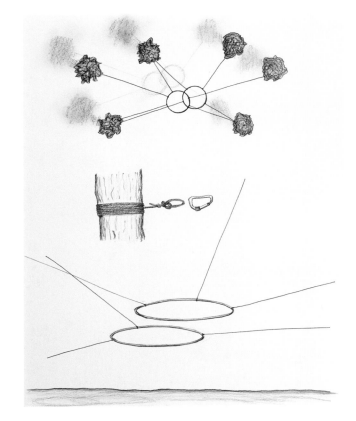

{fig. 49} IMA team members doing the bull ring initiative in the contemporary galleries

{fig. 50} Detail of the ball, rings, and strings in the bull ring initiative

{fig. 51} Sketch of *Team Building (Align)* from Bordwin's notebook

{fig. 52} Ames with astronomer Brian Murphy at Butler University's Holcomb Observatory

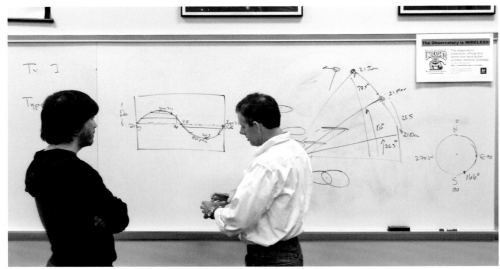

Dewey suggested that "an experience has a unity that gives it its name," and this unity is defined by "a single quality that pervades the entire experience in spite of the variation of its constituent parts."[38] With the team, Type A discovered the single pervasive aesthetic quality that dominated this team-building experience.

When Ames and Bordwin concluded their training at High 5, they were sitting around with other participants on the final evening and asked: "How do we explain this to anyone who's not here?" There was an obvious answer: "You don't."[39] There is no way to convey the exact meaning embedded in *Team Building (Align)* to the other publics who will encounter it. This is not because of the success or failure of the project, but is the simple by-product of experience itself—something that even Dewey understood was difficult to translate and convey immediately. I have tried here to demonstrate how *Team Building (Align)* developed from Type A's overall practice and to suggest how it emerged from the specific relationships between a group of people, a place, and a time. Subsequent writers will add their own layers of interpretation to the ones I have established here. There is much documentary material to be explored: the photographs and videos of the various team-building retreats, the video interviews and blog entries with the participants discussing their individual experiences, the IMA Type A documentary, and interviews conducted with the artists separately and together for this essay.[40]

The aesthetic experience of the *Team Building* project can only be characterized via abstraction, as an accumulation of many relationships and interpretations, a kaleidoscopic mixture that gives it form that can be analyzed and translated, even if only metaphorically. Closure of an experience is not separate or independent, but as Dewey said, it is the "consummation of a movement." Just as Type A has seen over the past twelve years, struggle and conflict can be enjoyed even if they are sometimes painful or difficult. Experience, much like an aesthetic idea, requires "reconstruction" and transformation, complex moves and changes. The pattern and structure of *Team Building,* and I would argue of Type A's collaborative practice, is alignment itself. It is what gives their work meaning, both literally, in relation to its participants, and metaphorically, with regard to the form of two separate circles merging into one.

38| Ibid., p. 37.
39| Ames and Bordwin 2008 (see note 1).
40| Many of these primary sources can be found on the IMA's Web site: www.imamuseum.org.

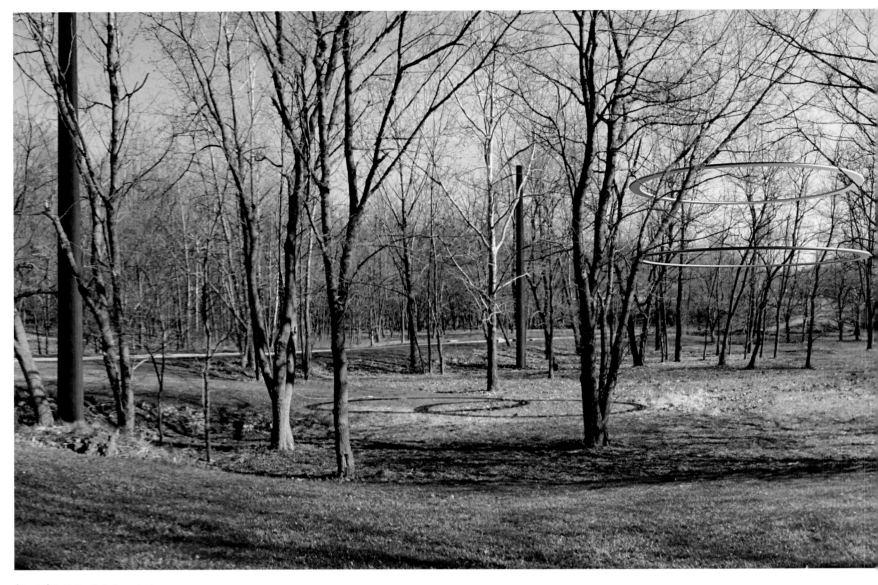

{fig. 46} Artist's digital rendering
for *Team Building (Align)*, 2009

THERE IS A MISCONCEPTION THAT GOOD WORK COMES FROM A COMFORTABLE PLACE. IT ACTUALLY COMES FROM A PLACE OF UNEASE.

{fig. 53} *Untitled (arm)* from
Insertions series, 2001
Chromogenic print, 30 x 40 in.

BARRIER: A BRIEF HISTORY

RICHARD KLEIN

Following the attacks by Al Qaeda on September 11, 2001, a siege mentality descended upon the United States. Fear and uncertainty were most keenly felt in urban areas, and especially in New York City. Public manifestations of this new reality included thorough airport screening of passengers and baggage, heavily armed National Guard troops in locations considered to be high-value targets, such as train and subway stations, and the ad hoc deployment of "Jersey barriers" as protection against truck and car bombs at sites that included Wall Street, City Hall, and Kennedy Airport. This transformation of public space did not go unnoticed by the two artists who call themselves Type A.

Type A had been utilizing the man-made urban environment as an active element in their work prior to 9/11, most notably in the photographic series entitled *Insertions* that was begun in the summer of 2001. *Insertions* brought the artists' figurative presence into the cold, anonymous environment of urban infrastructure, focusing on the concrete no-man's-land beneath highway overpasses and the marginal areas delineated by security bollards and traffic barriers. In the prescient work *Untitled (arm)* {fig. 53}, a seemingly disembodied left forearm hugs a concrete pillar, its form echoing the painted end of an adjacent Jersey barrier. A few short months later, rescue workers in lower Manhattan would be dealing with both disembodied flesh and shattered concrete not too far from where this photograph was taken.

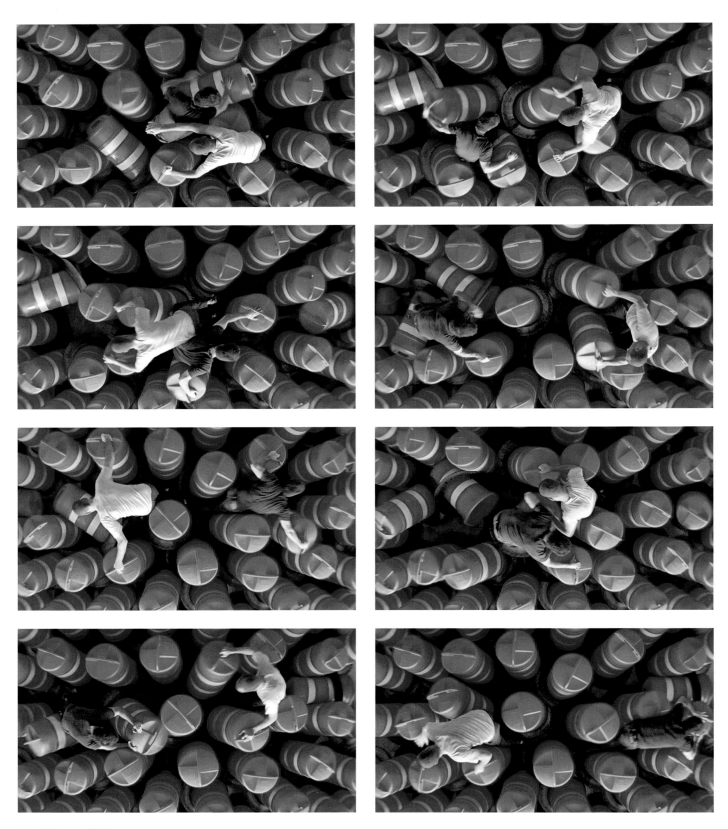

{fig. 54} *Barrel*, 2002
Multi-channel video, dimensions
variable

With the battle lines of America's new war drawn literally in Type A's former playground, their games of male competitiveness and aggression took on a new (and certainly different) urgency. If Type A's practice thus far had held a lens up to the artists themselves and the baggage they carried due to their Y-chromosomes, their new interest in the militarization of the city suddenly expanded their concerns from the personal to the geopolitical. The artists' competitive game-like performances had always touched on the psychology of aggression, but now there was an added layer, that most exaggerated form of social distortion: war.

One of the first works that resulted from this collision of the personal and the political was the multichannel video installation *Barrel* (2002) {fig. 54}. As in earlier works dealing with physical challenges, the duo were clearly competing against one another in their push to get through a sea of orange safety barrels; but more importantly, they were now assaulting objects used by governmental authority to protect and/or limit access. Where once the artists reenacted competitive sports-like activities, now they had crossed a line and were ominously attacking the symbolic boundary of the State—an act that if actually carried out in a public space would result in arrest. In the next several years, as civil liberties deteriorated during the Bush administration, Type A experienced the frustration and fear that were felt by many. "The real eureka moment for the two of us came sometime in the spring of 2006," Bordwin of Type A commented. "We went over to the West Side Highway to shoot more *Insertions* and related video inspired by orange traffic control devices, and there we rediscovered the concrete barriers {figs. 55, 56–59, pp. 88–91}. The conversation started after having discussed bollards with Kevin Biebel, the fabricator who makes security bollards and made our large sculpture *Prize (folly)* {fig. 68, p. 110}, in the summer of 2005. It's important to remember that all this was happening after the 2004 reelection of W [George W. Bush] and the outrage and resignation that followed."[1]

First, an accurate description: The work *Barrier* (in its current incarnation) takes the form of twenty-four identical concrete sculptures that are based on the form of the Jersey barrier,[2] the common concrete object that was originally designed for temporarily dividing highway lanes and blocking access to shoulders during construction. Each of the twenty-four sculptures, unlike a real Jersey barrier (which is straight), is curved in a sixty-degree arc that allows six of them to form a perfect circle with an outside diameter of thirteen feet and seven inches.

1| Type A, e-mail message to the author, October 7, 2009.
2| The Jersey barrier was first developed in 1955 at the Stevens Institute of Technology in Hoboken, New Jersey, under the direction of the New Jersey State Highway Department. It was created to help prevent vehicle crossover accidents in both construction and high-traffic areas.

Malcolm H. Ray and Richard G. McGinnis, *Guardrail and Median Barrier Crashworthiness: A Synthesis of Highway Practice* (Washington, D.C., 1997); Charles H. McDevitt, "Basics of Concrete Barriers," *Public Roads Magazine* 63, no. 5 (March–April 2000), pp. 10–14.

Each *Barrier* sculpture is three feet high and twenty-seven inches wide at the base (identical to a real Jersey barrier) and is ninety inches long in a straight line between the outermost base corners (shorter than the average Jersey barrier). As a modular sculpture, the work can be infinitely reconfigured each time it is installed; and like actual Jersey barriers, the installation scheme is dependent on the conditions at the site: the existing topography and architecture and the needs of traffic control versus access (both vehicular and pedestrian).

Considering the qualities of real Jersey barriers and of *Barrier* causes one to pause and reflect. Clearly, there is a difference between the two: *Barrier* was made as a work of art for aesthetic and philosophical exploration, while actual Jersey barriers are a design solution for a host of practical problems. But it is in thinking about this difference that things get really interesting. Jersey barriers were repurposed from the world of traffic control for use as security devices and, thus, transformed into both actual and symbolic boundaries of governmental and corporate authority. Type A has taken their actual and symbolic roles and tweaked them, turning them into objects that can still function in their intended original roles, while adding the weight of art history and social and political awareness. They are a curious hybrid, part minimal sculpture, part readymade, part protest song, and part potential utilitarian object. As these words are being written, *Barrier* is on a tour that includes the Tang Teaching Museum, the DeCordova Sculpture Park and Museum, and The Aldrich Contemporary Art Museum. At each of these institutions the artists will reconfigure *Barrier* to reflect the site, basing decisions primarily on aesthetics. But what if the cloud of war or insurrection were to descend across the countryside? The following is excerpted from the Aldrich Museum's Emergency and Disaster Plan[3] (emphasis added):

> *In the event of civil unrest, protest activities may be legal or illegal, depending on the situation. They are designed to attract attention, but can also turn violent should rioting or destruction of property occur. . . . A primary focus of security is to prevent intruders from entering the administration or Museum facility. . . . Work with law enforcement and help them to seal off and protect critical areas. Work with police to remove non-peaceful demonstrators and move peaceful demonstrators to areas such as the parking lot. . . . If necessary,* block access to the buildings with disabled vehicles or heavy objects to prevent trespass, vandalism, and looting.

3| The American Association of Museums requires a comprehensive emergency and disaster plan as a prerequisite for accreditation. Emphasis was placed on the development of these plans after the attacks of 9/11 and Hurricane Katrina.

{fig. 55} *Untitled (barrel 1)*
from *Insertions* series, 2007
Chromogenic print, 30 x 40 in.

In *Barrier,* form, material, history, aesthetics, and politics have coalesced to speak eloquently of the moment of uncertainty that we are currently experiencing. But perhaps more importantly, *Barrier* is a touchstone for deep currents that have helped form the modern world. If the parallels of history are infinite, the linear nature of *Barrier* reaches from our past into our future. History is filled with examples of barriers that were made to protect the nation-state. *Barrier,* however, has a dual nature, not only referencing the edge of sovereignty, but also—given the original purpose of Jersey barriers in delineating the edges of highways—alluding to the projection of political power along tracks and roadways.

This deep history might start (as with much in the Western world) with the Roman Empire. The consolidation of Roman power was based in no small measure on the empire's road system, a network that was developed primarily for military transport. Major Roman roads crossed Gaul and Britannia and aided in the subjugation of local populations. Many of these roads remained in use for centuries after Rome's collapse and are the foundations of many major European motorways. The First World War coincided with the widespread development of motorized vehicles, and after the war it was clear that the European road system that had been built for horse and carriage was insufficient for motorized military transport. In the United States, General "Black Jack" Pershing, who had commanded the U.S. Army in the First World War, became the first proponent of a nationwide defense highway system, which was finally authorized in 1956 by President Eisenhower (formerly Supreme Commander of the Allied Forces in Europe during the Second World War). Eisenhower had been impressed during the war with the German *Autobahn* network, and he understood the importance of rapid movement of both men and materials in wartime. The original plan of the American interstate system was based on military necessity, not on the commuting needs of the American public.[4]

Some would argue that the single largest undertaking of Roman engineering was Hadrian's Wall,[5] a physical barrier that secured and controlled the empire's northernmost border. Running 117 kilometers across the Tyne-Solway isthmus in northern England, it is a powerful reminder of Roman power, and looking upon its ruins today reminds one of other grand barriers made to control human activity: the Great Wall of China (halting the Mongol hordes); the Berlin Wall (thwarting the lure of democracy and the free market); the U.S./Mexican border (protecting

4| Tom Lewis, *Divided Highways: Building the Interstate Highways, Transforming American Life* (New York, 1997); *The States and the Interstates: Research on the Planning, Design, and Construction of the Interstate Defense Highway System* (Washington, D.C., 1991).
5| Publius Aelius Hadrianus was emperor of Rome from A.D. 117 to 138. For an overview of

the defensive wall that Hadrian initiated in A.D. 122, see Derry Brabbs, *Hadrian's Wall* (London, 2008).
6| Lynne C. Lancaster, *Concrete Vaulted Construction in Imperial Rome* (New York, 2005).
7| As of 2006, approximately 7.5 cubic kilometers of concrete were being made each year. This translates into more than one

cubic meter for every person on earth. U.S. Geological Survey Mineral Information Team, "Mineral Commodity Summary: Cement, 2007," http://minerals.usgs.gov/minerals/pubs/commodity/cement/index.html (accessed October 14, 2009).
8| The work of art that is clearly a pre-nineteen-sixties precedent to *Barrier* (as well as

to Minimalism's use of repetitive forms) is Brancusi's *Endless Column* (1937). But even this sculpture has a kinship with architecture and design, in that its form is derived from a pattern found in the carved wooden posts of Romanian folk architecture. See Ionel Jianou, *Brancusi* (Paris, 1963).

9| David P. Billington, *Robert Maillart: Builder, Designer, and Artist* (New York, 1997), p. 46.

the Anglophile United States from Latin American cultural and economic pollution). Of course, all of these historical barriers have been monuments to futility in varying degrees, their makers confusing the easily achievable restraint of people with the unstoppable forces of culture and commerce.

Barrier, like the original American interstate system, the German *Autobahns* and the Berlin Wall, is made of concrete. The Romans originally perfected concrete[6] (what didn't they perfect?) and its use grew exponentially during the twentieth century, becoming the primary fabric of both Modern architecture and infrastructure.[7] Considered in the light of material and structural history, *Barrier* has more early precedents (before the nineteen-sixties) in the world of architecture and engineering than of sculpture,[8] which helps in understanding its ability to delineate public space. For instance, at the Tang Museum *Barrier* was installed as two adjacent circles, creating "inside" and "outside" spaces {fig. 60}, echoing the curvilinear concrete architecture of figures such as Frank Lloyd Wright and Félix Candela. Wright in particular was obsessed with the automobile as an expression of modernity, and many of his visionary projects, including the *Gordon Strong Automobile Objective and Planetarium* (1924) and the *Crescent Opera, Civic Auditorium, Garden of Eden, Plan for Greater Baghdad* (1957), featured spiraling concrete ramps for vehicular access that planted the conceptual seeds that led to the modern concrete parking garage. But it is in works of civil engineering that *Barrier* has its deepest roots. The gentle curve of each segment of Type A's *Barrier* announces that they are not real Jersey barriers, but it also inexorably connects them to a universe of curved concrete structures that have helped master both human activity and natural forces. Perhaps the most important figure in this history is the Swiss engineer and designer Robert Maillart (1872–1940), whose work truly transcended engineering to become art (a solo exhibition in 1947 at the Museum of Modern Art helped canonize his work). Maillart was a seminal figure in the development of cast-concrete structures, pioneering the concrete hollow box, the concrete flat-slab floor, the thin-shell, deck-stiffened arch bridge, and, most germane to this conversation, the prefabricated concrete curbstone.[9] Type A's gesture of curving each segment of *Barrier* aestheticizes the work in an archetypal sense, so that it corresponds to that most classical of structural architectural forms, the arch, which appears in everything from the vertical flying buttresses of the Gothic cathedral to the massive horizontal

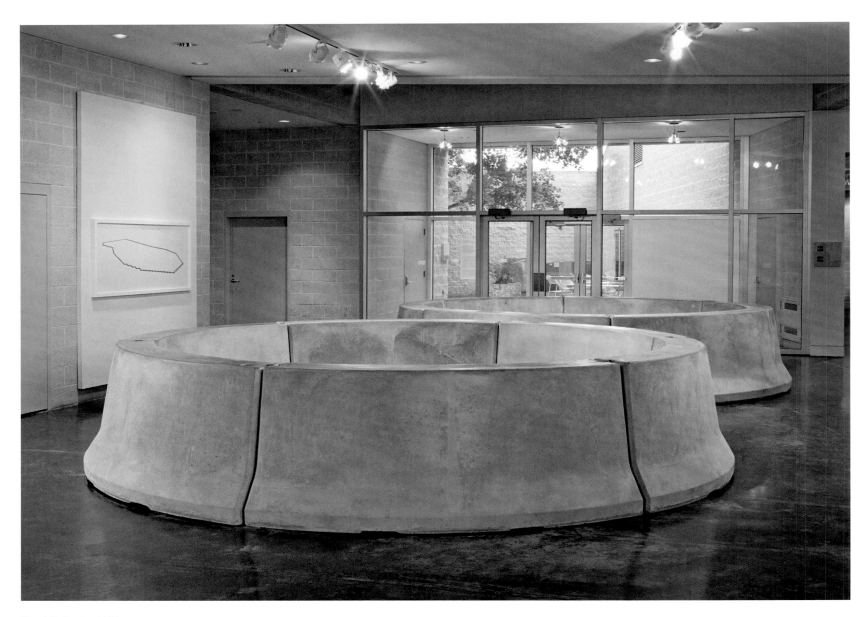

{fig. 60} *Barrier*, 2009
Glass-fiber reinforced concrete,
36 x 27 x 90 in. (each piece)
Installation view at the Tang
Teaching Museum and Art
Gallery, Saratoga Springs,
New York, September 2009

concrete arches of gravity dams such as Hoover and Glen Canyon on the Colorado River.

In the history of military anxiety, perhaps the most unusual structures that are doppelgangers for the individual segments of *Barrier*—both in form and protective function—are the hemispherical concrete "sound mirrors" that were developed by William Sansone Tucker, the British pioneer in acoustical research, in the wake of the First World War.[10] Troubled by the Kaiser's tentative attempts at bombing London during the war, the British realized the critical importance of early detection of approaching aircraft and, given the technology of the nineteen-twenties, decided that the detection of an approaching bomber's drone was a promising direction for research. The resulting acoustical mirrors that focused and amplified faint sound waves were constructed on the south and east coasts of England, facing across the Channel and the North Sea towards mainland Europe. (Oddly, one was constructed in Malta facing across the Mediterranean towards Sicily.) Unfortunately, the increasing speed of aircraft in the thirties and research into the reflection of radio waves (radar) quickly rendered the sound mirrors obsolete. The largest concrete mirror that still exists in Britain is at Denge, in Kent. It is two hundred feet across and twenty-six feet high and, together with the other smaller concrete mirrors at the site, creates an eerie spectacle that brings to mind a science fiction movie.

After the Second World War, the widespread use of concrete became synonymous with the utopia promised by Modernism. As the concrete ribbons of the interstate system stretched across the United States, new architecture that was not only made possible by the structural qualities of concrete, but was also based in the aesthetic of raw concrete surfaces, began to flourish. Major figures of the concrete aesthetic included Louis Kahn, John Lautner, and Paul Rudolph in the United States, and Le Corbusier, Oscar Niemeyer, and Pier Luigi Nervi overseas. But this futuristic utopia, like the concrete it was made of, soon began developing cracks. The public's reception of much of this new concrete architecture was downright chilly, and it was not helped by the massive public urban renewal projects of the nineteen-fifties and nineteen-sixties that were built in the name of progress but in many instances tore apart the fabric of inner-city neighborhoods. In 1954 the British architects Alison and Peter Smithson coined the term Brutalism (from the French *béton brut*, literally "raw concrete") to define a new aesthetic

10| For a thorough history of sound mirrors, see Richard Newton Scarth, *Echoes from the Sky: A Story of Acoustic Defence* (Hythe, 1999).

Ruled (plumb bob), 2009
Steel plumb bobs, string, cord
locks, installation dimensions
variable
Installation view at Goff +
Rosenthal Gallery, New York,
NY, September 2009

Ruled (plumb bob), 2009
Steel plumb bobs, string, cord
locks, installation dimensions
variable
Installation view at Goff +
Rosenthal Gallery, New York, NY,
September 2009

based in the pure expression of structural materials. Brutalism lived up to its name, becoming primarily known for public buildings made of cast concrete that had no apparent concern for visual amenity.

Two figures arose in the nineteen-sixties that are relevant to *Barrier*'s narrative: the English novelist J. G. Ballard and the American artist Robert Smithson. Both Ballard and Smithson were interested in the dystopian poetics of the desolate, modern man-made landscape and the belief in the inevitability of societal decline. Ballard's first book to use the oppressive concrete landscape of the motorway as a setting was *Crash* (1973), which dealt directly (and provocatively) with the violence and sexuality of the highway. But it was in his 1974 novel *Concrete Island* that he significantly broadened his metaphor of infrastructure as a symbol of modern life. The protagonist of *Concrete Island,* architect Robert Maitland, drives his Jaguar through a motorway barrier, falling into a no-man's-land between motorway overpasses. Injured and ignored by passing traffic, he becomes a modern-day Robinson Crusoe, scavenging food thrown from passing vehicles. A passage from *Concrete Island* evokes the mood of both *Barrier* and the *Insertions* series:

> *Maitland looked up at the high causeway of the overpass. After the days of rain the concrete had soon dried out, and the white flank crossed the sky like the wall of some immense aerial palace. Below the span were the approach roads to the Westway interchange, a labyrinth of ascent ramps and feeder lanes. Maitland felt himself alone on an alien planet abandoned by its inhabitants, a race of motorway builders who had long since vanished but had bequeathed to him this concrete wilderness.[11]*

11| J. G. Ballard, *Concrete Island*
(New York, 1974), p. 149.

{fig. 58} *Ruled (base)*, 2009
Rubber baseball bases,
each: 12 x 12 in., installation
dimensions variable

{fig. 61} Robert Smithson, *New Jersey–New York (Map 13)*, 1967
Map, photo, ink, pencil on paper, 22 x 18 in.
Estate of Robert Smithson
Courtesy James Cohan Gallery, New York
© Estate of Robert Smithson / Licensed by VAGA, New York

Robert Smithson, along with Minimalist artists that included Sol LeWitt, Donald Judd, and Carl Andre, constructed modular sculptures that are precursors to *Barrier*'s industrially made repetitive form. Indeed, Andre's abstract grids of metal plates formally resemble *Ruled* {fig. 58}, another work by Type A, in which the artists assembled a Minimalist grid of plastic baseball bases on the floor.[12] Although Andre's gesture of working horizontally was in part a rejection of traditional totemic "male" verticality in sculpture, his total embrace of cool nonrepresentation was as masculine as it gets. By contrast, Type A's sculpture is never completely abstract, but rather filled with allusions to both the artists themselves and the real world. It is this self-conscious awareness of their masculinity (and its accompanying behavior) that separates them from high Minimalism by more than just time.

Smithson was obsessed with both infrastructure and marginal industrial landscapes. His photographic collage *New Jersey, New York with 2 Photos* (1967) {fig. 61} takes a map centered on New York Harbor and inserts two photographs of the highway median areas between opposing lines of traffic. In *Concrete Pour* (1969) and *Asphalt Rundown* (1969) {fig. 62} Smithson documented via photography the spill of unused cement from a concrete truck into a ravine and the dumping of hot asphalt down a hillside, both gestures referencing the processes of road construction and contrasting the control usually manifested by man-made materials with the entropy inherent in geologic forces. Similarly, Type A's gesture of curving the original Jersey barrier's form is a subtle repudiation of the absolute control promised by the real barriers. Writing in 1972

{fig. 62} Robert Smithson, *Asphalt Rundown*, Rome, Italy 1969
Estate of Robert Smithson
Courtesy James Cohan Gallery, New York
© Estate of Robert Smithson / Licensed by VAGA, New York

12| *Ruled (base)* premiered in an exhibition at Goff + Rosenthal, New York, in September 2009, along with the grid-like installation *Ruled (plumb bob)*.

about his earthwork *Spiral Jetty*, Smithson mused on how the curved form of the piece rejects pure rationality:

The "curved" reality of sense perception operates in and out of the "straight" abstractions of the mind. The flowing mass of rock and earth of the Spiral Jetty *could be trapped by a grid of segments, but the segments would exist only in the mind or on paper . . . but in the* Spiral Jetty *the surd takes over and leads one into a world that cannot be expressed by numbers or rationality.*[13]

Perhaps it is pure coincidence, but Smithson was born in Passaic, New Jersey,[14] not far from where Jersey barriers were perfected (as luck would have it, the form that was used to make the mold for *Barrier* was CNC-milled in Jersey City). The landscape of northern New Jersey was both industrialized and suburbanized earlier and faster than much of the greater New York metropolitan area (the first highway cloverleaf interchange in the United States was built in Woodbridge Township in 1929)[15] {fig. 63}, and this development has left a mark on the American consciousness that continues to the present day. Architect-turned-Minimalist-sculptor Tony Smith had his famous epiphany in this landscape, and his observation was cited as an influence by Smithson:

{fig. 63} Woodbridge Cloverleaf, New Jersey, 1928

When I was teaching at Cooper Union in the first year or two of the fifties, someone told me how I could get onto the unfinished New Jersey Turnpike. I took three students and drove from somewhere in the Meadows to New Brunswick. It was a dark night and there were no lights or shoulder markers, lines, railings, or anything at all except the dark pavement moving through the landscape of the flats, rimmed by hills in the distance, but punctuated by stacks, towers, fumes, and colored lights. This drive was a revealing experience. The road and much of the landscape was artificial, and yet it couldn't be called a work of art. On the other hand, it did something for me that art had never done. At first I didn't know what it was, but its effect was to liberate me from many of the views I had about art. It seemed that there has been a reality there that had not had any expression in art . . . the experience on the

13| Robert Smithson, "The Spiral Jetty" (1972), originally published in *Arts of the Environment*, ed. Gyorgy Kepes. Reprinted in *The Writings of Robert Smithson*, ed. Nancy Holt (New York, New York, 1979), p. 113.
14| "Has Passaic replaced Rome as the Eternal City?" Smithson quipped in his essay "The Monuments of Passaic," originally published in *Artforum*, December 1967. Reprinted in *The Writings of Robert Smithson* (see note 12), p. 56.
15| "Woodbridge History and Tour," from the official website of Woodbridge Township, New Jersey, http://www.twp.woodbridge.nj.us (accessed September 18, 2009).
16| Tony Smith, interview by Samuel Wagstaff, Jr., "Talking with Tony Smith," in *Minimal Art: A Critical Anthology*, ed. Gregory Battcock (1968; Berkeley, 1995).
17| © Bruce Springsteen, ASCAP.

road was something mapped out but not socially recognized. I thought to myself, it ought to be clear that's the end of art.[16]

That same landscape engendered the following lines forty years later:

New Jersey Turnpike ridin' on a wet night 'neath the refinery's glow,
out where the great black rivers flow
License, registration, I ain't got none but I got a clear conscience
'Bout the things that I done
Mister state trooper, please don't stop me
Please don't stop me, please don't stop me . . .

In the wee wee hours your mind gets hazy, radio relay towers lead me to my baby
Radio's jammed up with talk show stations
It's just talk, talk, talk, talk, till you lose your patience
Mister state trooper, please don't stop me
Hey, somebody out there, listen to my last prayer
Hi ho silver-o, deliver me from nowhere

Bruce Springsteen, "State Trooper" (1982)[17]

This sense of travel and restlessness and a description of a landscape that has become "nowhere" is, of course, the classic expression of the American experience. Americans have always been the most adrift from precedent, and their culture has had (at least until recently) a limitless, frontier-like aspect. Perhaps the last great monument to the American frontier is the St. Louis Gateway Arch. Designed by architect Eero Saarinen (another Modernist who is known primarily for his pioneering work in concrete) and completed in 1965, it was built to commemorate the westward expansion of the American empire. It is ironic that it was completed at the same moment that artists were challenging the whole notion of "monuments," for it was in the mid-sixties that the belief in utopia was finally and irrevocably replaced (despite the hippie movement) by a dystopian view as expressed by figures such as Ballard and Smithson. The year 1965 also saw Claes Oldenburg's drawing *Proposed Colossal Monument for Park Avenue, N.Y.C.—Good*

Humor Bar {fig. 64}, a huge anti-monument of a popsicle with a bite taken out of it, which if it had been constructed would have been a barrier to vehicular traffic on one of Manhattan's major north-south thoroughfares.

This deflation of high Modernism and the accompanying heroic concept of the monument led to a series of works of art that, at least in appearance, could be considered to be the immediate predecessors to *Barrier.* These included Smithson's *Spiral Jetty* (1970), which took the form of the common utilitarian masonry structure that is used to protect harbor entrances, curved back upon itself to represent the entropic spiral of geologic time; Christo and Jeanne-Claude's *Valley Curtain* (1971), which combined sculpture, architecture, and engineering with public dialogue to create a temporary fabric barrier across a Colorado canyon; and Richard Serra's famous *Tilted Arc* (1981), a curved, barrier-like sculpture of steel installed diagonally across New York City's Federal Plaza. *Tilted Arc* was designed by Serra to really be a barrier of sorts, with its purpose, however, being kinesthetic not political, forcing the viewers to become aware of their location and movement through the public plaza. The acrimonious public hearings in 1985 that preceded *Titled Arc*'s removal included an odd, prescient moment that looked forward to *Barrier*'s genesis: One of the criticisms leveled at the sculpture was that it could be used by terrorists to direct a bomb's blast towards the adjacent government buildings.

The work that comes closest to a parallel summary of the historical forces that shaped *Barrier* is Anselm Kiefer's 2002 sculpture *Étroits sont les vaisseaux (Narrow are the Vessels)* {fig. 65}. Kiefer's sculpture is an eighty-foot-long pile of broken corrugated pieces of reinforced concrete. As with *Barrier,* its horizontality

18| From Type A's Web site,
http://typea.us/ (accessed
October 12, 2009).
19| Paul J. Browne, chief
spokesman for the New York
City Police Department, quoted
in Cara Buckley, "Chinatown
Residents Frustrated Over Street
Closed Since 9/11," *The New York
Times,* September 24, 2007.

negates any pretense to monumentality, and its relationship with the history of concrete connects it inexorably with militarism and war. *Étroit sont les vaisseaux* is a blasted wall, a collapsed highway, a debris pile from any war one chooses from the past century, and the remains of Modernism itself. *Étroit sont les vaisseaux* as a physical object, however, has a beginning and an end and unchanging composition, while the individual sections of *Barrier* can be reproduced ad infinitum and can be infinitely reconfigured depending on necessity. Type A has begun to create a series of prints entitled *Barrier (Proposal to Protect)* that "offer plans to fortify a variety of locations by completely surrounding each with a winding row of barriers. . . . Each proposal can be realized with the proper interest and budget."[18] Just as "rapid response forces" replace the conventional standing army, *Barrier* has been created to be deployed quickly and easily wherever a threat materializes (or a potential exhibition opportunity presents itself). If *Étroit sont les vaisseaux* is the ruins of the Berlin Wall, *Barrier* is the perimeter of Camp Delta: a "temporary" node for prosecuting the global war on terror.

Driving on the American highway one sees the currently popular bumper sticker that reads "End this War" with "this" crossed out and replaced with an apparently handwritten "less." *Barrier* is also endless, like this seemingly continual state of war with its strategic goal of a worldwide, general suppression of Islamic fundamentalism. As we enter the second decade of the twenty-first century, the barriers surrounding the Green Zone in Baghdad are being relocated to the urban areas of Afghanistan, and the New York City Police Department has long-term plans to "redesign its guard booths and security barriers to make them more attractive."[19] *Barrier* signals the final closing of the frontier: it is the new, iconic antimonument to American experience.

Provincetown, September–October 2009

{fig. 56} *Untitled (crush)* from
Insertions series, 2007
Chromogenic print, 30 x 40 in.

{fig. 57} *Untitled (no-go)* from
Insertions series, 2007
Chromogenic print, 30 x 40 in.

{fig. 58} *Untitled (wrapped)* from
Insertions series, 2007
Chromogenic print, 30 x 40 in.

{fig. 59} *Untitled (street barrier)*
from *Insertions* series, 2007
Chromogenic print, 30 x 40 in.

EVERYTHING WE MAKE HAS OURSELVES IN IT, EITHER LITERALLY OR AS STAND-INS. IN MANY WAYS, WE'RE STAND-INS FOR OURSELVES.

Untitled (milk), Frame 3 of 5 from
Spittakes series, 2000
Chromogenic print, 14 x 19 in.

BUILDING: A DIALOGUE WITH TYPE A

IAN BERRY

BUILDING BLOCKS

IAN BERRY: Did you go to art schools? What did an artist look like to you when you started?

ANDREW BORDWIN: I went to NYU [New York University] and never planned to go to art school. I wanted to use the darkrooms in the photo department and they wouldn't let me without enrolling, so I did. I was there for junior and senior years, ending up with a split BA/BFA [Bachelor of Arts/Bachelor of Fine Arts] degree. My conception of what an artist was wasn't fully formed at all. I spent a lot of time playing and touring and recording with a band at that time and was pulled away from photography by that. In the end, I guess my goal was to be a commercial photographer.

ADAM AMES: I majored in communications but studied some photography and film while an undergraduate and finished with an MFA in photography and related media from the School of Visual Arts in 1997. Prior to grad school, I interned with John Coplans. He was a mentor, though not the kind of artist I wanted to be. While he was intelligent and insightful, he was quite cranky and seemingly lonely. I did like the fact that he was coming to art late in life and on his terms. In terms of inspirations, I'd have to say that I wanted to be David Cronenberg or Sam Raimi, artists/directors with strong personalities who did not follow trends (this was before Raimi did the Spiderman movies). I was most inspired by heavy

metal bands, mainly thrash. I still have a tendency towards what might be considered "cult," lesser known but greatly appreciated by a strong and vocal few (or fewer).

IAN: How did you first meet?

ADAM: Part of my wife Sara's graduate school thesis at NYU was to have a salon in our apartment. She wanted to showcase artists and organize a series of dinners with curators, artists, and collectors to promote their work. Andrew was the second in the series. We met and did not get along (there was some insulting). But our spouses conspired to get us together. We wound up becoming friends. I helped Andrew with some video editing. We wound up spending a lot of time together during these editing sessions, lots of talking.

ANDREW: We began to collaborate by accident, really. That show with Sara Meltzer was in 1997, and it's true we didn't like each other much in the beginning, but Adam began helping me with some editing work and pretty soon the two of us were comfortable enough with each other that he asked me to help him shoot a video. The piece—what became *Dance* {figs. 3, 8, pp. 23, 29}—was a collaborative effort and Type A was born.

IAN: Was that the first work you made together?

ANDREW: *Dance* was the first piece, but that was Adam's work. The first piece we made as an official collaborative team was *4 Urban Contests* {fig. 4, p. 25}, and that was done very shortly after *Dance* was shot in April 1998.

ADAM: In the spring of 1998, I had an idea for a video that involved my getting beaten in a wrestling match. Andrew was the only artist I knew who could look convincing on a wrestling mat. We worked together on the look and choreography of the piece. After a strenuous shoot and some strenuous editing, we realized it was not just my piece. We spoke about it and decided to come up with a name for the two of us. Sara suggested Type A. We wanted to use a name that was not just "Ames/Bordwin" or "Ames + Bordwin." So we went for the third thing and, in a sense, branded ourselves Type A.

IAN: What did your artwork before Type A look like?

ANDREW: In many ways different from Type A's work, in many ways similar. My way of using a camera to construct a frame found an outlet in many of our projects, and in this way Adam and I were and continue to be in sync. We use the camera collaboratively. But I had never dealt with pop culture in my work and had

never spent that much time with video. My solo work started out as conventional photography in the mold of Adam Bartos and Stephen Shore and Joel Sternfeld and so on, and at some point around 1995 I decided that I wanted to stop doing that. The work Sara showed was a series of Iris prints of fuzzy houses and landscapes, and then a series of Cibachromes made from old film I had found in my parents' house.

IAN: How did it change when you started working together?

ANDREW: It changed completely. One important aspect is that I had humor in the art for the first time. I never worked with that. At one point, Adam told me flat out that he thought it was strange that for someone who loved being funny, my work was devoid of humor. I took that to heart. I also had a chance to deal with wide areas of interest which I'd never explored, such as pop culture, sports, the business world, and Conceptual [Art] strategies as a whole.

ADAM: My work before Type A looked a lot like Type A work. I was always in it. Video was mostly single-shot, though I did get into more extensive editing as editing became more accessibly available (meaning: easier). There was a decidedly horror-movie influence in subject matter and style.

IAN: Is it harder or easier to work as Type A as opposed to solo?

ADAM: Yes.

ANDREW: On balance, I would say it's much easier, and more fun—much more prolific and productive.

IAN: Do you divide "jobs" in the studio? Does one of you do the drawing, one the photography, one the modeling, one the texts, etc.?

ANDREW: I do all the pencil renderings as well as most of the Photoshop work. Adam does all of the video work and all the Web-based work. We do all the writing work collaboratively.

ADAM: We play to our strengths. Technically, there are things that one of us can do better (or at least more efficiently). Andrew is the still photo guy. I'm the video guy. But that has more to do with setup and post-production. When it comes to framing a shot, we're both hands-on. One will start it and the other will tweak it, back and forth, until it is done. When it comes to choreographing an action, it's both of us.

IAN: Your earliest works fit into a history of conceptual work that references identity and gender—maleness, competition, etc. Can you talk about your relationship to that history?

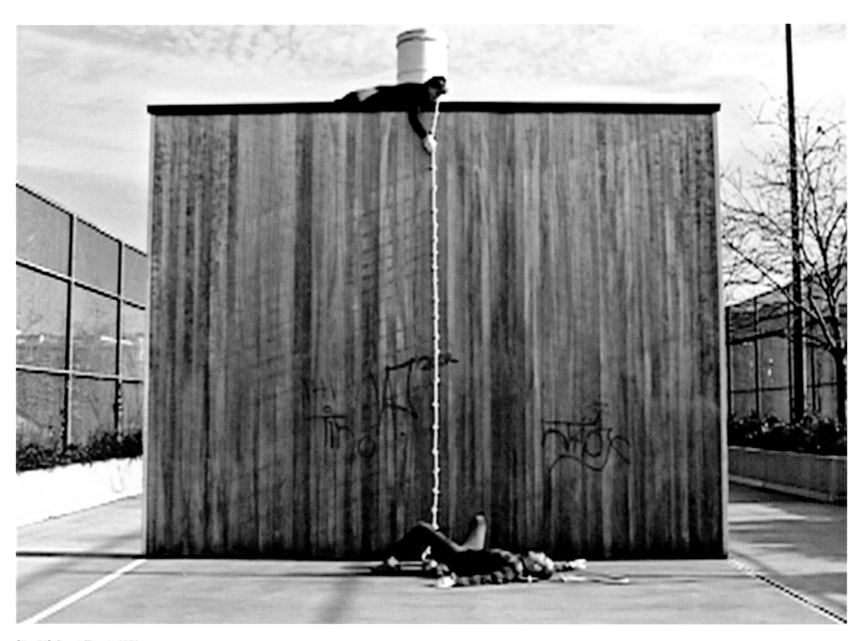

{fig. 72} *Reach/Reach,* 2001
Two-channel video, 1:50 min.

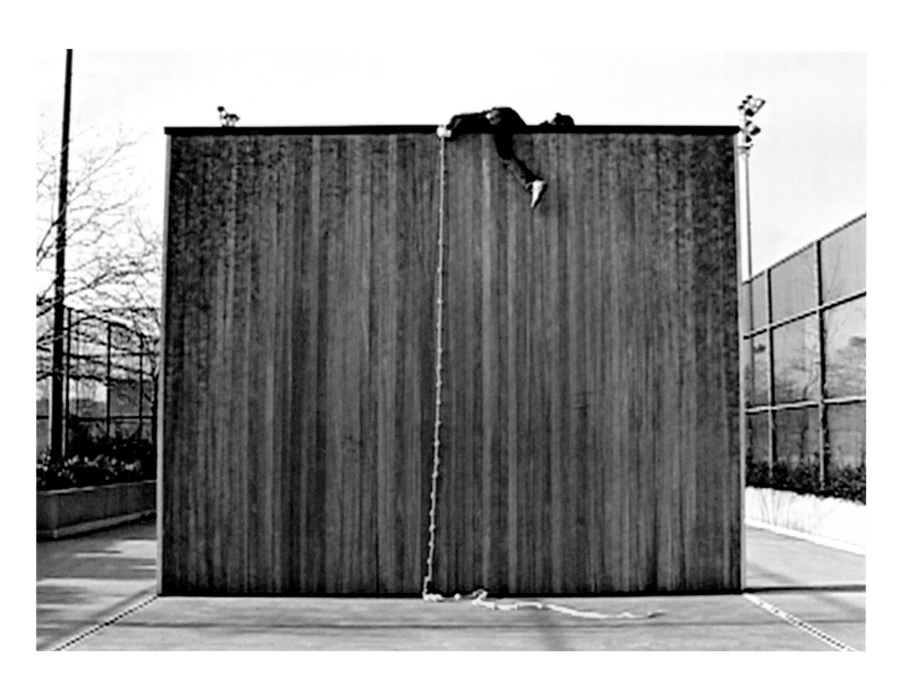

ADAM: I'm definitely aware of that work, though I wouldn't call it encyclopedic. At SVA, I learned about [Bruce] Nauman, [Vito] Acconci, [Bill] Viola (mainly performative video works), [Chris] Burden, [Joseph] Beuys . . . but was also schooled in photographers and video artists, though I wouldn't call myself a fanboy of those artists. The focus on maleness and masculinity has been gestating for a long time. Between the heavy metal, horror/action films, comic books, I've been focused on the stuff of boys/men all my life. How that translates into an adult, society-based masculinity is still in process.

ANDREW: The work we did from 1998 through 2000 forms the foundation of everything we do. It's like a childhood and adolescence. You're glad you had it, it informs who you are, but you're on to other things and you don't want to go back to it. When we made *Mark* {figs. 15–17, pp. 36-40}, I began to think that one day we'd look back at those early pieces and think of them with a sort of nostalgia as a young and unformed basic vocabulary. I still think of them that way.

IAN: Is everything you make a variation of a self-portrait?

ANDREW: Everything we make has ourselves in it, either literally or as stand-ins. In many ways, even when we're in our work, we're stand-ins for ourselves.

ADAM: I would say yes. Whether the work has us in picture or video, everything we do is a translation of who we are and where we are in our lives, though not necessarily at the moment that the work is made. In other words, our lives are filtered into the work whether we know it or not. Because we're constantly reflecting on things and open to things being modified as needed. It's a living thing (cue ELO).

BUILDING A TEAM

IAN: How did you propose the Indianapolis piece to the museum?

ANDREW: We were walking around the park, and ropes courses started popping in our head. We started talking about building a ropes course and team-building people. When we sat down with the curator and said "We want to team-build your staff," it so happened that she was interested in these very ideas. I remember us talking about how we wanted to do something that was going to be direct and engage people rather than just making an object.

ADAM: And to work with the community in Indianapolis. When we were first offered a commission, Andrew looked at an overhead view of Indianapolis, and the park was very central. Our piece addresses the layout of the city.

IAN: Your original concept revolved around a process that would try to make an active public artwork, not solely a static monument.

ANDREW: We believe that art should involve direct experience. Very often the object can get in the way. In this case, we wanted to connect with the institution itself and do something that could change as it evolves. Experiential Education (team building) is playing games and sort of letting go, and ultimately involves working on a low ropes course and a high course which puts you in a situation of danger, artificially inducing a state of risk within a safe context so your mind and body start to work in ways that they normally wouldn't. You start to realize who you are and learn a lot about yourself.

ADAM: It's like experiencing art. You risk something, something may be challenged or fractured in order for you to break through into a new way of thinking.

IAN: How did you learn about team building?

ANDREW: We trained with a company in Vermont called High 5 that conducts experiential education courses but also trains professionals—we had to learn how to handle a group.

ADAM: When we were there, they would say things like "We're just playing games, but you guys are making art." We kept talking about the definition of art. We were asked to explain our project several times, and kept returning to this idea of offering people an experience without leading them, without saying it's going to be a good one or a bad one, and just letting them have it. That was the definition we were being given of experiential education, and that matched what we were thinking of as art.

IAN: What did they say to you?

ANDREW: Jim Grout just kept saying it: "That's different."

ADAM: I guess he never thought about art that way and what he did that way. All of a sudden this idea of a big sculptural object at the end started to come into question. We went back and forth and started looking at the sculpture as growing out of the experience of our training.

ANDREW: It was hard. In the beginning Adam was more into the idea of this not being an object.

IAN: It would be an event?

ADAM: No object.

ANDREW: But the reductive path can be a slippery slope. You keep boiling and

boiling and boiling down until you reach this final nub of truth. I think that you were a lot more reluctant to make an object, and I'm very respectful of that, the fact that you were focused on "the piece is the work, it's a gesture, it's just a gesture, we don't need to have an object."

IAN: Is that how every project goes in the studio?

ANDREW: Swinging back and forth? Absolutely.

IAN: When you are spinning ideas around in the studio, are you both part of that brainstorming?

ANDREW: Generally. I want to get to the point, and I'll just start chopping away everything in an attempt to get there. I'm never thinking, if I chop something away, it's gone. I'm just trying to clear it and then we can bring it all back.

IAN: Are you conscious of your process, or do you just do it?

ANDREW: We are by now. We spend a lot of time together, so we figured out a lot of stuff. We've had our moments of conflict, our moments of great contentment, and everything in between. In the course of doing it, we see patterns and we try to leave the ego at the door. Every so often we take a step back and notice how we work. But it's different with every project.

ADAM: In scheduling our meetings with the team-building group, we needed to come up with a program to figure out our objectives. Once we figured that out, then we figured out what we needed to do to achieve that, and the activities we wanted to do. We've gotten into huge fights because I would say, "We're doing this and we're not doing that," and he would say, "Well, let's consider all of this," and it got very tense. Then we figured out what we wanted to do and came out with an agreement, which is what we tend to do.

By the third session, there was no tension—it just flowed. Going through the team-building training, we actually became facilitators. Reflecting on how we do things has helped us become a better team. It sounds kind of corny, but the fact is we become a better team by helping people become better teams. It's given back to us in ways that we weren't expecting.

IAN: I can imagine the team-building people might think, "Hey, these aren't real team builders; they are just using us for their project," and the museum is saying, "Hey, these guys are doing this team-building thing. How is it art?" Each side is pushed by your project. Did you feel that?

ADAM: They are a less cynical bunch. When we came up there, I think we kind

of surprised them that we would even do it. And, honestly, why would two New York artists come to Brattleboro, Vermont, and want to look at what experiential educators are doing to make it into art? They were fascinated by our project.

ANDREW: I think they doubted our sincerity a little bit.

ADAM: I don't think they thought we were having one over on them, but I think they thought maybe we had other ideas that we weren't telling them about.

IAN: Like you were going to make fun of them?

ANDREW: We are absolutely sincere about every single thing we do. We've never made anything that is ironic.

ADAM: We don't deal in irony.

ANDREW: Team building has appeared in pop culture in some very disparaging ways. I keep bringing up *The Office,* and even in the *Flight of the Conchords* video, she [the character Sally, played by Rachel Blanchard] is wearing a ratty old team-building t-shirt. You see it from time to time. Experiential education essentially grew out of Outward Bound and has become wrapped up in the whole self-help movement that pretty much grew up further back than the seventies and sixties. People automatically think this is a culty thing or something.

ADAM: When we first saw it, we thought it was kind of funny. We went online. There are some things that are just outright funny. There is a team-building group that called themselves WITS, which is an acronym for something or another, but they are stand-up comics and they do this and that. It does have tremendous potential for humor.

IAN: The history you are talking about has interesting overlaps with how Type A works—your investigations about each other and about being men and being in a world where the traditional family structure doesn't rule anymore and men and women are sometimes confused about their roles.

ANDREW: There is role-playing involved in our work and there is self-examination, and a lot of it does come down to behavior patterns and sociology.

ADAM: It was less about the gender. When our team-building mentors Jim and Jen work together, sometimes they step on each others toes, sometimes their styles clash. Other times they get out of the way of the other one, and sometimes they work seamlessly, depending on the day of the week. That echoed what we did when we were doing team-building stuff at the museum. Sometimes it was incredibly smooth; other times we stepped on each other.

ANDREW: It is built-in that men will find themselves performing a certain role, women may find themselves behaving in a certain way, and then you talk about it, or you make observations about it. It has to do with listening. It really has to do with actually opening up your ears and listening, and who's going to step up and take a role, who's going to lead. There is room for personality and idiosyncratic patterns of behavior to step forward, and a lot of that is tied to gender, but it's rarely broken down that way.

In many ways I describe us as idealists. Everything we've done together is a big "what-if." We are idealists about this community of two. We are a community of two, and we constantly allude to that in the way we conduct our days.

ADAM: We started out being head-to-head. Literally the first shot, the first thing we ever made is a shot of the dance piece where we enter the frame head-to-head, where we wrestle and beat each other up, and the majority of the stuff that followed involved competition and one of us trying to outdo, outperform, or one-up the other. There was humor in it: formative, expulsive, very masculine. Then at some point we got to be closer, maybe two or three years in, and we became better friends. Not to say there wasn't tension, but we each brought different things and the end result was Type A. We started looking at collaboration and how our relationship works—the intimacy and chemistry that we have, which a lot of men won't talk about.

This may be the first thing that we've done that is purely us as a team. We are not exploring collaboration—we are just collaborating. So I think the work we've done mirrors our relationship, and this is just the stage we are in now. We want to engage other people; we want to have stuff come back to us and affect our relationship.

IAN: For the most part, you make things—photographs, videos, sculpture. Were you itching to be out in public?

ANDREW: The Addison piece is where that changed.

IAN: Was that your first piece that was not just the two of you in the studio making a thing?

ANDREW: Yes.

ADAM: We did one other piece with a third person, the artist Jason Middlebrook. He blocked my light.

ANDREW: That was a fun piece that involved drinking beer and falling over. We've

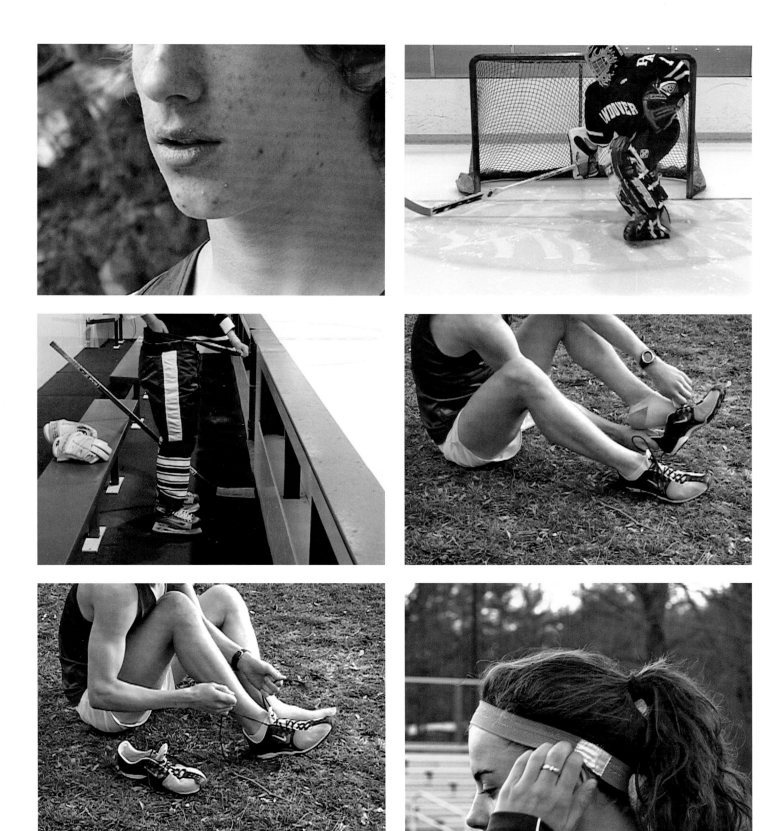

{fig. 66} *Jinx*, 2006
Multi-channel video, looped,
dimensions variable

always said that we were stand-ins for ourselves in our videos. We just happened to be the ones available to do the work. So we keep using ourselves, and it's about us because we are making the work, but it's not about us because it can be about you too.

ADAM: The Addison was the first time we engaged the community.

ANDREW: The Addison Gallery of American Art is at Phillips Academy, and we had a bunch of kids reenacting their superstitious ticks and habits that they performed for a game or a practice {fig. 66}. Another work involved having cheerleaders write a cheer for us.

ADAM: There are two different groups, and at some point the idea came up with having the pep squad outside the Addison cheering people as they came into the museum; and then the SLAM crew at some point would do a full-on performance in the middle of the gallery, which they did, in uniform, loud as could be. We saw the people from the board of directors, older people, looking around . . . they had no idea what was going on—this had never happened. We wanted to get these uncommon things together to see what happens {figs. 27, 28, p. 49}.

ANDREW: We are interested in sports . . . we are interested in pop culture . . . we are interested in art for art's sake. We are interested in a lot of different things. But the kids who are on the hockey team aren't necessarily going to look at beautiful work at the Addison, and the kids who are hanging out at the Addison aren't necessarily going to be on the wrestling mat all the time. Everybody is separated, which happens within the art world as well. It's a private conversation for so few people.

IAN: Do you like to provoke people with your work because there is some reality that doesn't exist that you want to see?

ADAM: . . . and to break down dangerous assumptions. You can see people making assumptions about what they think they are supposed to be doing, what they think people want them to make, and what they think their role is. Those assumptions are very limiting.

IAN: Are you frustrated with how people look at you?

ADAM: For years we were thought of as the guys from the pissing video.

ANDREW: . . . or are you guys going to fight?

ADAM: We like to think there is depth to the work. We make photographs, we make sculpture, and we're making drawings, but we're still often labeled video

artists. We like people to see the more comprehensive view of what we do. I like that idea of pushing people out of where they are comfortable, and those that I look up to do that.

IAN: Who are you thinking of?

ADAM: People like George Carlin. Most everything he said challenged the status quo and notions of complacency. Nothing was off-limits. I am in awe of how he could talk about taboo subjects and not only make you laugh, but make you think. If I have the tiniest bit of his ability, then I'm happy.

ANDREW: I'd go straight to music. I would say Joe Strummer or Johnny Lydon (except that he's turned out to be a complete windbag) or 1966 Pete Townsend.

IAN: Why those rockers?

ANDREW: Because they stripped away pretense and said, "This is the way it is. This is the reality of it." That position is provocative. Just doing that can piss people off because people want to be comfortable. There is a misconception that good work comes from a comfortable place. It actually comes from a place of discomfort. It comes from a place of unease.

ADAM: Carlin went after people who took themselves too seriously. He had lots of establishment targets.

ANDREW: That's the whole point of punk rock.

IAN: Their target was often industry. So—if I combine those two examples—the thing you would want to alter is our inattention to the reality right around us?

ANDREW: That'd be a good start.

ADAM: It's an act of fooling oneself, almost a delusional quality. When people make assumptions, it's often a protective device. When you teach, it's so clear that many of the students are suffering under assumptions of what they are supposed to do and who they are supposed to do it for.

IAN: As a curator, I look at things that are happening in the world and have ambitions to make transformative opportunities for people to change through their interactions with art and exhibitions.

ANDREW: We feel the same way about what we do.

ADAM: We like getting down to specific things, whether it's one person or a hundred people. Art doesn't reach everyone; it doesn't have to. It's imperfect, and it's something that brings us happiness.

ANDREW: It's the one thing we know how to do. It offers a place. Team building is

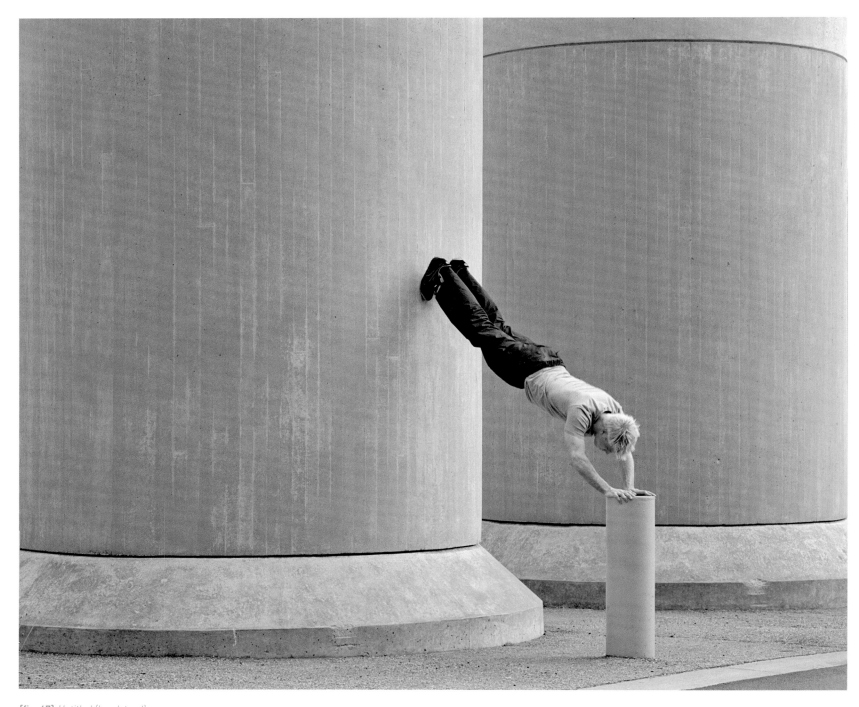

{fig. 67} *Untitled (handstand)*
from *Insertions* series, 2001
Chromogenic print, 30 x 40 in.

all about offering an opportunity, and our sculpture offers a place where people can gather. It offers an event space, and it also is in some ways a commemoration of gathering together. Our piece [for the Indianapolis Museum of Art] offers a place for a conversation about the role of the museum, the role of the 100 Acres park, what a museum should be within a community, what is the role of art. I'd like to think that these discussions in some way have changed the community in Indianapolis, as it has us in the studio.

BUILDING A BARRIER

IAN: Why make a sculpture out of Jersey barriers?

ADAM: I'm not sure when we first started noticing them, but it was definitely post-9/11, when they were used as ad hoc anti-terrorist devices. We used the city as our playground prior to that. We'd go out and shoot video, take photographs, just run around and do whatever we wanted. Post-9/11 there was a crackdown on anything that was suspicious-looking. If you were taking a picture of anything, especially near government property, they started enforcing this rule that you can't use a tripod. If we were climbing somewhere, they'd tell us to stop. We kept seeing barriers.

ANDREW: We saw them around police headquarters, around important state and federal buildings . . .

ADAM: . . . and some not-so-important places too. You would see them on the side of the road, next to buildings, and you would assume the buildings were important, because they were being blocked.

IAN: The first works in the series were photographs of you in and around barriers?

ANDREW: We started taking the *Insertions* photographs before 9/11.

ADAM: We started shooting that series during the spring and summer of 2001. By the fall of 2001 we really noticed the restrictions, and realized how different it was going to be from now on. There is one picture that does contain a Jersey barrier very overtly. We were looking at this brutalist architecture, poured concrete structures, garages and on-ramps to upper levels of places . . .

ANDREW: . . . we were concealing ourselves or inserting ourselves into them so that we became structurally part of them {fig. 67}.

IAN: Showing a leg, showing an arm . . .

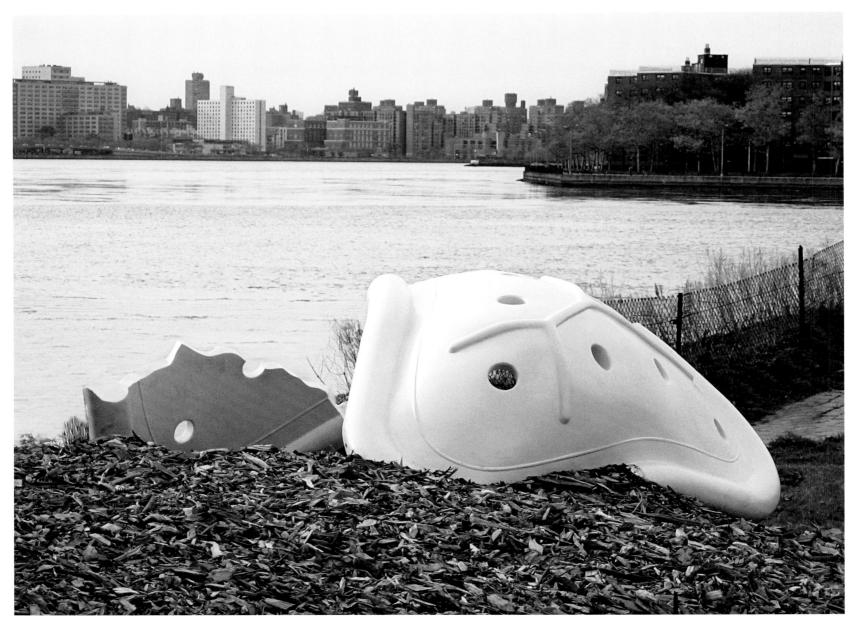

{fig. 68} *Prize (folly)*, 2005,
welded aluminum, auto body
paint, 6 x 4⅘ x 2 ft.
Installation view at Socrates
Sculpture Park, Long Island City,
NY, 2005

ANDREW: . . . parts of our bodies. Appreciating concrete as a medium, as a structural medium, and tying into our interest in masculine mediums and those issues, but these disembodied body parts in concrete took on different meanings.

ADAM: The first one that we thought we nailed is this one where I'm doing a kind of inverted handstand, almost like an inverted push-up. It's somewhat triumphant. It's got a physical bond between me and the concrete to it. As the series continued, our bodies got more chopped up, more hidden, and more crushed by the stuff. Within a couple of months we started noticing the restriction in movement, how we were casually told we could and couldn't go certain places, and how we willingly accepted this as a new part of our life.

IAN: You couldn't go to those places because of fear?

ADAM: Right, because of fear. I remember, at that point, we were bothered by the reality that what followed this horrible event was that we were suspect and were being told we have to give up these freedoms, giving up the freedom to move around. There was a sentiment that, yes, you trade these freedoms because you don't want to be attacked again.

IAN: What is "hardening"?

ANDREW: Hardening is a term that's used primarily by the insurance industry to describe the process by which a building is rendered to be safe from attack. It usually means installation of bollards, primarily, which are anti-traffic posts that block stuff, so you can't drive a truck bomb into a building. The idea is that by installing these objects you are preventing that from happening by setting up a safe perimeter.

ADAM: In late 2004 we started a project that was called *Prize (folly)* {fig. 68}, a six-foot-tall fallen and broken athletic cup that we worked on with a guy named Kevin Biebel at J. Frederick Construction in Connecticut. He had these bollards around and told us that he was quickly cornering the market on this specific kind of bollard—the one that was used around the Time Warner building, which was being built at the time.

ANDREW: He became an approved vendor for the government.

ADAM: We saw a couple of these bollards in the waiting room of his shop. We thought they were ash cans, and then he started telling us, well, it's not really someone who is planning how to stop a terrorist attack. It's when insurance companies say it's good enough. I don't remember how soon after that that the idea

of working with Jersey barriers came up, but the idea of somehow aestheticizing them became our project.

ANDREW: To go back to the *Insertions*, the second iteration of that project involved us not so much in a structural, playful sense but much more as victims of these objects, being crushed by them. I always say that our *Barrier* project was a direct response to the Bush administration and its policies following these attacks. We had a big political motivator—both of us shared that frustration, with this layer of fear placed on top of a layer of threat that we found very suspect.

IAN: Your Jersey barriers have a curve. Do real Jersey barriers come with a curve?

ANDREW: None of them.

IAN: None?

ADAM: In order to make a curve, they stagger them slightly. We wanted to attempt to aestheticize them because the first step in hardening is just to plop down these devices outside of buildings. Then, of course, people figured they could make money by getting architects to harden the building during construction. So a lot of buildings you see now are structurally sound to fend off trucks. We wanted to say that you can aestheticize it, or attempt to, but the fact is they're still these big dumb pieces of concrete that should be seen and critiqued.

ANDREW: A lot of things have changed.

ADAM: People are willing to accept these devices. People are willing to accept being controlled because it's for their own safety.

IAN: If you're frustrated by this outward symbol of a false sense of security or a symbol of fear, why insert them into museums?

ANDREW: In the street, these objects are not questioned the same way. I think the idea of learned helplessness, becoming immune to the questioning that can be raised by these objects, is revived in this environment. It is an environment where movement is clearly a matter of choice, divorcing objects from function, adding a level of absurdity to some degree, which is something we always like to do in our work.

IAN: They are still functioning as an obstacle.

ANDREW: The function should remain. It should remain an inconvenience.

IAN: It's okay that they are frustrating to many viewers?

ANDREW: That's the point.

TYPE A

Proposal to Protect: 815 N Broadway, Saratoga Springs NY 12866

258 Barriers

{fig. 69} *Proposal to Protect:*
815 North Broadway, Saratoga
Springs, NY 12866 (tech sheet),
2009
Archival inkjet print, 13 x 19 in.

{fig. 70} Angle view of *Proposal to Protect: 815 North Broadway, Saratoga Springs, NY 12866*, 2009
Archival inkjet print, 30 x 72 in.

ADAM: You protect the targets that are most valuable. Then, when those are all protected, there is going to be another level of targets, which are maybe not equally as valuable but just as targetable, so you protect them, and then there is going to be another level beyond that, and on and on and on. So the idea that we come to the Tang [Teaching] Museum [at Skidmore College], or the Aldrich [Contemporary Art Museum], or the DeCordova [Sculpture Park and Museum], which are not targets in the same way the World Trade Center was, or the Federal Reserve. It's taking this rational idea to an irrational extreme. Any community is going to be in danger if you follow this logic—this logic of fear. If you follow it that far, then you're going to have to start protecting everything, because soon everything is going to be a target {figs. 69, 70}.

ANDREW: It's a bit of an invasion to put them here in the museum.

IAN: Tell me a little bit about what they're made of.

ADAM: Concrete.

IAN: Are they solid concrete?

ANDREW: They are made out of glass-fiber reinforced concrete. That allows them to have a thin wall with a Styrofoam plug in the middle. They sound as if they are solid, and as you approach them, they have the mass and gravity of the real thing. Eight hundred to a thousand pounds is not light, but it's easy enough to move, and when you knock on them, they sound as though they are solid. They give that impression of being immobile. That said, even though we spend a lot of time on the

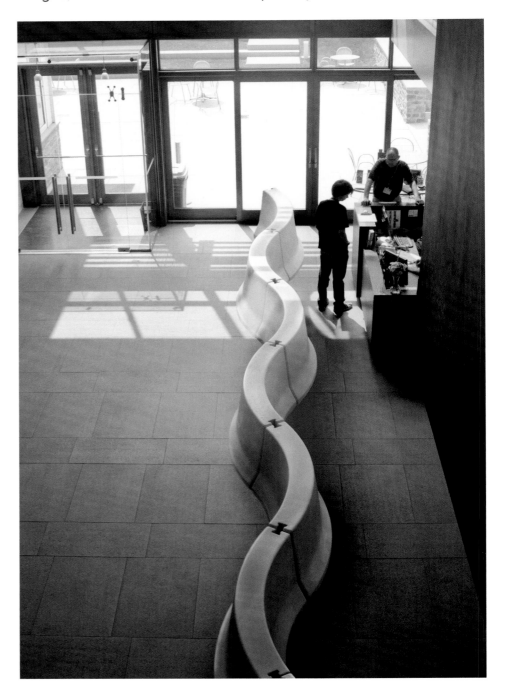

{fig. 71} Photo composite rendering for *Barrier* (proposed installation at The Aldrich Contemporary Art Museum), 2007

materials of our work, we are always driven by the idea, and the medium comes after. The medium serves the idea.

IAN: When you imagine the different variations of the project from site to site, are you thinking about the idea of the piece changing, or just the form?

ANDREW: Both. We are thinking about how those things are twisted together, so whatever form it takes can take on another conceptual meaning, or vice versa. The idea at the Aldrich is running them straight through the building's entrance. Obviously, we are creating sides, we're creating a very long imposing barrier, and by cleaving the area in two, it also references the idea that we are two people, we have sides {fig. 71}. Here [at the Tang], the idea of having it be focused around two circular centers also suggests a possible self-portrait of us. This has a whole other meaning, and yet it still is imposing in terms of traffic. It becomes a huge barrier to get around, but the feeling is different.

ADAM: We're responding to the spaces. We're going to be sensitive to what's being offered and what we can do.

IAN: There's an absurd part of this piece too, a strange thing in the wrong place. The notion of it not functioning or the notion of it being curved—it's kind of silly.

ANDREW: It's out of context, and that makes it strange right off the bat.

IAN: This is maybe one of your less overtly humorous pieces, but it still has that strange quality. What do you get from this strangeness?

ANDREW: It allows for accessing the viewer in a quick and easy way. If someone is on stage and they start making the audience laugh as a whole, all of a sudden you have this unified hall full of people that are doing the same thing; they all share this event. They all share this reaction, which they didn't necessarily share before. So it's a big unifier and it's a big access point like humor, is a way in, and then there is usually something behind that that perhaps is a little more lasting.

ADAM: But it's not quick and it's not easy. The humor that we go to tends to be disruptive, tends to be about a rift, like a fight that might go on a little too long, a reveal that makes people in a social situation feel discomfort. I always look at humor as being violent. A pun is funny because the words that you base your logical life on and your system of thinking on has been turned around in one word. It's not used the way you expected it, and the only response you can have other than running and screaming is to let it out in a laugh. Uncomfortable humor is what I think we bring.

ANDREW: Usually accompanied by nervous laughter.

ADAM: When we're in the studio, we're making a lot of work that's about separation, that's about cleaving an area, mine and his {fig. 72, pp. 98–99}. Our work has a lot to do with dividing, and we're a team, we're working together, but we're focused very much on division. I think humor grows out of that contradiction.

ANDREW: I would also say, in some ways when you're making something that expects a reaction from another person—whatever that may be, whether it's visual art or music, how[ever] you define that reaction—the complexity to that reaction sometimes can get in the way. Laughter is so elemental. It's one of the first things we learned to do as babies. So I think, in a way, it's a nice building block to use. In addition, we like to enjoy what we do and we like sketch comedy. We like what we did when we started working together, sharing our sense of humor. That's a big part of what brought us together.

ADAM: There's a masculine level of performance to be funny; to get girls to like you, you make them laugh, that kind of thing. So I think men are primed to act out in a way that is very traditional, and that is something that we bonded over. If we have a studio visit, we're trying to make you laugh in a way to engage, but it also is playing up that masculine tendency to perform.

ANDREW: It can make people relax a bit, but not always.

ADAM: Some people are just not funny.

ANDREW: Crash and burn.

ADAM: Andrew can tell you many, many times when his humor has just fallen flat and it was embarrassing for all of us.

ANDREW: Hey!

Curtain Call, 2004
Single-channel video, 9:28 min.

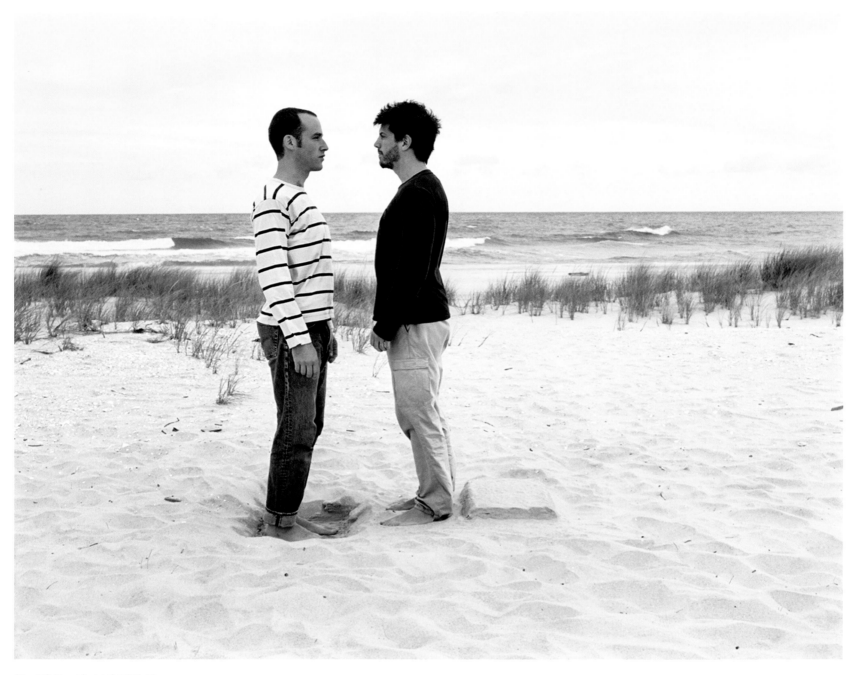

{fig. 19} *Stand (height)*, 2002–03
Chromogenic prints, 24 x 30 in.
(each)

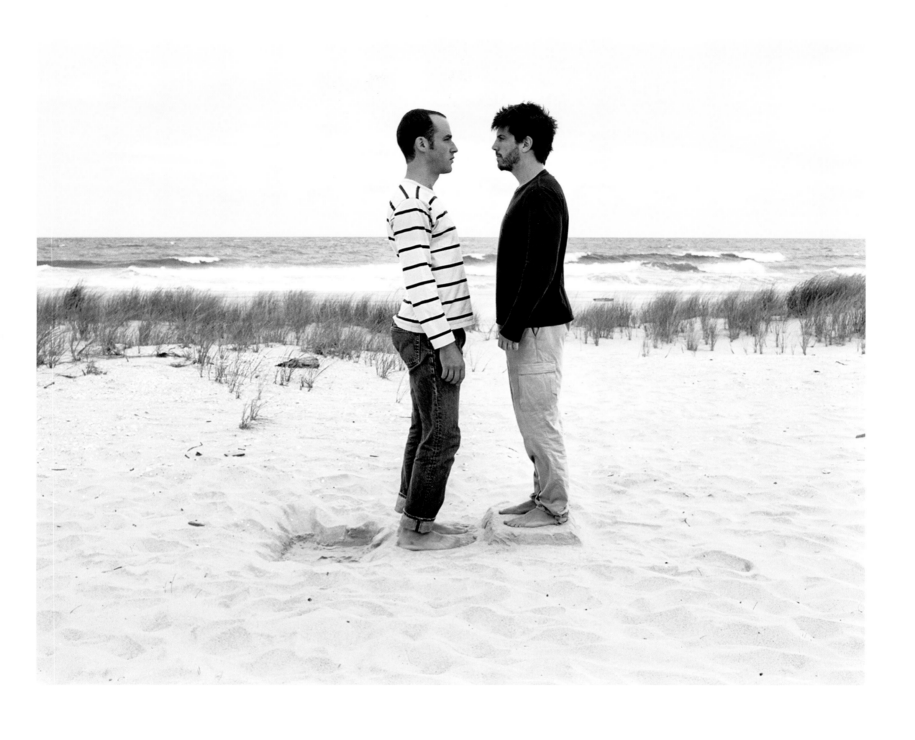

CHRONOLOGY

Type A is the collaboration of
Adam Ames and Andrew Bordwin.
Established in 1998, Type A is based in New York.

ADAM AMES
1969 Born in New York
1997 MFA in Photography and Related Media, School
 of Visual Arts, New York
1994 General Studies in Photography, International
 Center of Photography, New York
1991 BA in Communications, University of Pennsylvania,
 Philadelphia

ANDREW BORDWIN
1964 Born in Framingham, Massachusetts
1987 BA in Classical Civilization, BFA in Photography,
 New York University, New York

TYPE A

RESIDENCY

2005–06 Edward E. Elson Artists-in-Residence,
Addison Gallery of American Art, Andover,
Massachusetts

SOLO EXHIBITIONS

2011
Barrier, The Aldrich Contemporary Art Museum,
Ridgefield, Connecticut

2010
Barrier, DeCordova Sculpture Park + Museum, Lincoln,
Massachusetts

2009
Ruled, Goff + Rosenthal, New York
Barrier, The Frances Tang Teaching Museum and Art
Gallery at Skidmore College, Saratoga Springs,
New York

2007
Media Test Wall: Type A, The List Visual Arts Center,
Cambridge, Massachusetts

2006
Artist's Project: Type A, Addison Gallery of American Art,
Andover, Massachusetts
Contender, Santa Barbara Contemporary Arts Forum,
Santa Barbara, California

2005
Curtain Call, Sandroni Rey (Project Space), Los Angeles
The Black Box, Selected by Anne Ellegood, Omar López-
Chahoud and Shamim Momin, ARCO, Madrid

2004
Push, Sara Meltzer Gallery, New York
Type A: Spittakes and Selected Videos, Second Street
Gallery, Charlottesville, Virginia
Damage, Sara Meltzer Gallery, New York

2003
Mark/Point/Stand, Sara Meltzer Gallery, New York

2002
The Pre-Career Retrospective, California State University,
Luckman Fine Art Complex, Los Angeles (catalogue)
Insertions, Ten in One Gallery, New York

2000
Roadhouse, Ten in One Gallery, New York
Breathe, Ten in One Gallery (sideshow), New York

GROUP EXHIBITIONS

2010
Framed, Indianapolis Museum of Art, Indiana
100 Acres: The Virginia B. Fairbanks Art & Nature Park,
Indianapolis Museum of Art, Indiana

2009
Rip Off, Armand Bartos Gallery, New York
Endurance, Abington Arts Center, Jenkintown,
Pennsylvania

2008
Ashes For Breakfast, Goff + Rosenthal, New York
IN>TIME Performance Series, Curated by Mark Jeffery
and Sara Schnadt, Chicago Cultural Center, Illinois

2007
Merit Badge 2, organized by Jason Middlebrook, Rockland
County Museum of Art, Rockland, New York

What's Your Hobby, curated by Beth DeWoody,
The Fireplace Project, East Hampton, New York

2006
Armed, curated by Nadine Wasserman and Rachel
Seligman, Mandeville Gallery at the Nott Memorial,
Union College, Schenectady, New York (catalogue)
New York Video Festival, Film Society of Lincoln Center,
New York
Strange Instrument, 3rd Ward, Brooklyn, New York
Prevailing Climate, Sara Meltzer Gallery, New York
Out of Context, Art Omi, Ghent, New York
Iron Artist, organized by Matt Freedman, Sina Najafi,
and Colby Chamberlain; P.S.1, Long Island City, New York
(catalogue)
In Focus: 75 Years of Collecting American Photography,
Addison Gallery of American Art, Andover,
Massachusetts
Welcome Home, Sara Meltzer Gallery, New York
Skirting the Line: Conceptual Drawing, curated by Katie
Johnson, Richard E. Peeler Art Center, DePauw
University, Greencastle, Indiana

2005
New Tapestries, Sara Meltzer Gallery, New York
Sport, Socrates Sculpture Park, Long Island City,
New York
Merit Badge, organized by Jason Middlebrook, Craryville,
New York
Dating Data, Josée Bienvenu Gallery, New York
Regarding Clementine, Clementine Gallery, New York
Special, Kustera Tilton Gallery, New York
The Voting Booth Project, Parsons Gallery, New York
Beginning Here: 101 Ways, Visual Arts Gallery, New York

2004
Will Boys Be Boys?, curated by Shamim Momin for
Independent Curators International, The Salina Arts
Center, Salina Kansas; Museum of Contemporary Art,
Denver, Colorado; Herbert F. Johnson Museum of Art,
Cornell University, Ithaca, New York; The Gulf Coast
Museum of Art, Largo, Florida; Indianapolis Museum of
Art, Indiana
ArtFORCE, artists' video series curated by Yvonne Force,
broadcast on Plum TV
Screwball, Vox Populi, Philadelphia
The Squared Circle: Boxing in Contemporary Art, curated
by Olukemi Ilesanmi, Walker Arts Center, Minneapolis,
Minnesota (catalogue)
The World's a Mess, It's in My Kiss, Debs & Co., New York

2002
Time Share, Sara Meltzer Gallery, New York
Dangerous Beauty, curated by Pearl Gluck, The Jewish
Community Center, New York

2001
Chelsea Rising, curated by David Rubin, Contemporary
Art Center New Orleans, Louisiana (catalogue)
Tent, Centrum Beeldende Kunst, Rotterdam,
The Netherlands
Good Humor, ECP, New York and Pollux, Berlin
Freestanding, Beaver College Art Gallery, Glenside,
Pennsylvania
From Steel to Flesh, curated by Lisa Wainright, IUN
Gallery for Contemporary Art, Indiana University
Northwest, Gary, Indiana
*Selections from Art in General: A Program of Short
Video Works,* Instituto Cubano del Arte e Industria
Cinematográficos, Havana
Video Marathon, Art in General, New York
Never Never Land, curated by Omar López-Chahoud,
Florida Atlantic University Gallery, Boca Raton, Florida

2000
Balls, James Cohan Gallery, New York
Game On, Sara Meltzer Gallery, New York (catalogue)
Achieving Failure, curated by Bill Arning, Thread Waxing
Space, New York; Cleveland Center for Contemporary
Art, Ohio
"Representing": A Show of Identities, curated by Katherine
Gass and Ingrid Schaffner, The Parrish Art Museum,
Southampton, New York
Making Time, curated by Amy Cappellazzo, Institute of
Contemporary Art, Palm Beach, Florida; Armand
Hammer Museum, University of California, Los Angeles
(catalogue)
The Standard Projection: 24/7, curated by Yvonne Force,
The Standard Hotel, Los Angeles
Manly, curated by Grady T. Turner, Art in General, New York

1999
New Media Space, Herbert F. Johnson Museum of Art,
Cornell University, Ithaca, New York
International Photography Biennale, Centro de la Imagen,
Mexico City (catalogue)
Zapping Zone, Galerie Hubert Winter, Vienna
*Frequent Flyer: Recent Short Video Works from New York
and Los Angeles,* New York
Hang Time, curated by Debra Singer and Lauren Ross,
White Columns, New York (catalogue)

Luster, Henry Urbach Architecture Gallery, New York
I'm the Boss of Myself, Sara Meltzer's On View, New York
(catalogue)
Three Suitcases, curated by Laurie De Chiara and Omar
López-Chahoud, Art & Idea, Mexico City
Paradise 8, selected by Henry Urbach, Exit Art/The First
World, New York
International Juried Show, selected by Lisa Dennison,
New Jersey Center for Visual Arts, Summit, New Jersey

1998
5th Annual Gramercy International Contemporary Art Fair,
Henry Urbach Architecture, Chateau Marmont, Los
Angeles
The Selective Eye, Anne Reed Gallery, Sun Valley, Idaho
TwoMANYTwo, presented by MANY, Musicians & Artists
in New York, DCTV, New York
Recursion, Flipside Gallery, Brooklyn, New York
Scope 1, curated by Pip Day, Artists Space, New York

PUBLIC COLLECTIONS

Addison Gallery of American Art, Phillips Academy,
Andover, Massachusetts
Herbert F. Johnson Museum of Art, Cornell University,
Ithaca, New York
Indianapolis Museum of Art
The Israel Museum, Jerusalem

BIBLIOGRAPHY

2009
Sheets, Hilarie M., "Serious Play," *Art in America,*
November 2009, pp. 176–83.

2008
Hoppe, David. "Art, Nature and Change at the IMA."
NUVO (Indianapolis, Indiana), August 6, 2008, www.nuvo.
net/articles/art%2C_nature_and_change_at_the_ima
(accessed September 23, 2009).

2007
Bjornland, Karen. "Loaded With Symbolism." *The Daily
Gazette* (Schenectady, New York), January 18, 2007, p. D1.
Reverend Jen, "Diary of an Art Star." *Artnet,* August 21,
2007, www.artnet.com/magazineus/features/jen/jen8-21-
07.asp (accessed September 23, 2009).
Wasserman, Nadine, and Rachel Seligman. *Armed.*
Exh. cat. Mandeville Gallery, Union College. Schenectady,
New York, 2007.

2006
Bennett, Lennie. "Boys to Me." *St. Petersburg Times*
(Florida), May 21, 2006.
Chan, Sewell. "On Your Mark, Get Set, Create Something
Arty." *New York Times,* June 12, 2006, p. E1.
Comingore, Amy. "Stand By Your Man." *Daily Nexus
Online* (University of California, Santa Barbara),
January 19, 2006.
Freedenberg, Molly. "Making Fun of Manliness."
The Santa Barbara Independent, March 16, 2006.
Kane, Tim. "'Armed' and Whimsical, Not Dangerous."
Times Union (Albany, New York), December 10, 2006.
Masters, H.G. "Art in the City: Fun with Dairy." *The L
Magazine* (New York), August 30, 2006,
www.thelmagazine.com/4/17/art/artinthecity.
cfm?ctype=2 (accessed September 23, 2009).
Molon, Domic. "Two Men, On: Restraint and Intensity in
the Work of Type A." In *Type A: Contender.* Exh. cat. Santa
Barbara Contemporary Arts Forum, California, 2006.
Pollack, Barbara. *Iron Artist: Type A.* Exh. cat. P.S. 1 Con-
temporary Art Center. Long Island City, New York, 2006.

2005
Harper's Magazine. "AA<—>AB/200(c) 7/28/04."
Harper's, February 2005, p. 25.
Ross, Lauren. "Dating Data." *Art on Paper,* May/June
2005, pp. 28–29.

2004

Harvey, Doug. "Ranking the Museums." *LA Weekly*, January 1, 2004.

Jana, Reena. "Push and Pull." *Art on Paper* 9, no. 1 (September 2004), pp. 28–29.

Pollack, Barbara. "The Elephant in the Room." *Art News*, September 2004, pp. 118–19.

Schwendener, Martha. "Type A." *Time Out New York*, November 18–24, 2004, p. 84.

2003

"Critics' Picks." *Time Out New York*. March 20–27, 2003, p. 85.

Ilesanmi, Olukemi. *The Squared Circle: Boxing In Contemporary Art*. Exh. cat. Walker Art Center. Minneapolis, Minnesota, 2003.

Krenz, Marcel. "Type A: Mark/Point/Stand." *Contemporary* (Vienna), no. 50, 2003.

Levin, Kim. "Spring Arts Preview." *Village Voice*. March 5–11, 2003, p. 76.

——. "Voice Choices." *Village Voice*, April 2–8, 2003.

Ostrower, Jessica. "Type A at Sara Meltzer." *Art In America*, December 2003, pp. 102–03.

Pollack, Barbara. "Type A: Mark/Point/Stand." *Time Out New York*, no. 392 (April 3–10, 2003), p. 57.

2002

Arning, Bill. *Type A: The Pre-Career Retrospective*. Exh. cat. Luckman Fine Arts Complex, California State University. Los Angeles, 2002.

Garcia, Sandra. "New York 'Type A' Guys Display Art in Luckman." *University Times* (California State University), December 5, 2002.

Levin, Kim. "Spring Arts Preview." *Village Voice*, March 5–11, 2002, p. 76.

Schwendener, Martha. "Type A." *Artforum*, April 2002, 139–40.

Speh, Scott. "Type A at Ten in One." *Fucking Good Art*, no. 10 (April 2002).

2001

Bookhardt, D. Eric. "Been There, Viewed That." *Gambit Weekly* (New Orleans), February 27, 2001, p. 26.

Harvey, Doug. "About Time." *LA Weekly*, February 16–22, 2001, p. 33.

Knight, Christopher. "The Complex Art of Capturing Random Moments." *Los Angeles Times*, February 17, 2001, p. F1.

Lunenfeld, Peter. "Urine Nation." *Artext*, no. 72 (February–April, 2001), p. 36.

Rubin, David. *Chelsea Rising*. Exh. cat. Contemporary Art Center New Orleans. New Orleans, 2001.

"Type A." *(t)here* (New York). Issue 5.

2000

Arning, Bill. "Out to Stud." *Time Out New York*, no. 230 (February 17–24, 2000), p. 58.

Cappellazzo, Amy. *Making Time*. Exh. cat. Palm Beach Institute of Contemporary Art. Palm Beach Florida, 2000.

Cotter, Holland. "Innovators Burst Onstage One (Ka-pow!) at a Time." *New York Times*, November 10, 2000, p. E34.

Gavilan, Ana Isabel Perez. "Three Suitcases." *Art Nexus*, no. 34 (November–January 2000).

Griffin, Tim. "Game On." *Time Out New York*, no. 250 (July 6–13), p. 62.

Hunt, David. "Balls." *Time Out New York*, no. 255 (August 10–17, 2000), p. 61.

Johnson, Ken. "Game On." *New York Times*. July 14, 2000. Art Guide, p. E30.

Levin, Kim. "Voice Choices." *Village Voice*, August 1, 2000.

——. "Voice Choices." *Village Voice*, November 7, 2000, p. 103.

The New Yorker. "Manly." *New Yorker*, February 21, 2000, p. 50.

The New Yorker. "Manly." *New Yorker*, February 28, 2000, p. 50.

The New Yorker. "Balls." *New Yorker*, August 14, 2000, p. 13.

Porter, Jenelle, and Conny Purtill. "Game On." Exh. cat. Sara Meltzer Gallery. New York, 2000.

Robinson, Frank. "Weekend Update." *Artnet*, March 30, 2000, http://www.artnet.com/Magazine/reviews/robinson/robinson3-30-00.asp (accessed September 24, 2009).

Schwan, Gary. "A Thoughtful Debut: Museum's First Show Looks at Film, Video and Time." *Palm Beach Post* (Florida), March 12, 2000.

——. "'Never Never Land' Is No Disney Utopia." *Palm Beach Post* (Florida), November 19, 2000.

Turner, Grady T. "Aperto New York." *Flash Art* 33, no. 213 (Summer 2000), pp. 57–60.

1999

Arning, Bill. "Hang Time." *Time Out New York*, no. 201 (July 29–August 5, 1999), p. 51.

Caniglia, Julie. "Hang Time." *Sidewalk.com*, July 1999.

Cappellazzo, Amy. "I'm the Boss of Myself." Exh. cat. Sara Meltzer's On View. New York, 1999.

Johnson, Ken. "Hang Time." *New York Times*, July 23, 1999. Art Guide, p. E36.

Santamarina, Guillermo. *International Photography Biennale*. Exh. cat. Centro de la Imagen. Mexico City, 1999.

Singer, Debra, and Lauren Ross. "Hang Time." Exh. cat. White Columns. New York, 1999.

CONTRIBUTORS

LISA D. FREIMAN

Lisa D. Freiman is chair of the Department of Contemporary Art at the Indianapolis Museum of Art (IMA). She also serves as director of the IMA's 100 Acres: The Virginia B. Fairbanks Art & Nature Park, an urban oasis for experimental, commissioned, site-responsive artworks adjacent to the museum's main campus. Prior to joining the IMA, Freiman worked as assistant professor of art history, theory, and criticism at the University of Georgia, Athens, and served in the curatorial department of the Institute of Contemporary Art, Boston. During her eight-year tenure at the IMA, Freiman has sought out and supported the work of emerging and established international artists through major traveling exhibitions, commissions, acquisitions, and publications. Her publications on contemporary art include *Amy Cutler* (2006) and *María Magdalena Campos-Pons: Everything Is Separated by Water* (2007).

RICHARD KLEIN

Richard Klein is an artist, curator, and writer. He is currently exhibitions director of The Aldrich Contemporary Art Museum in Ridgefield, Connecticut. His recent major curatorial projects have included *Fred Wilson: Black Like Me* (2005), *No Reservations: Native American History and Culture in Contemporary Art* (2006), and *Elizabeth Peyton: Portrait of an Artist* (2008). He was responsible for organizing the production and exhibition of Type A's *Barrier* project, a collaboration between the Tang Museum at Skidmore College, Saratoga Springs, New York; the DeCordova Sculpture Park and Museum, Lincoln, Massachusetts; and The Aldrich Contemporary Art Museum.

IAN BERRY

Ian Berry is associate director and Susan Rabinowitz Malloy Curator of the Frances Young Tang Teaching Museum and Art Gallery at Skidmore College, Saratoga Springs, New York. His projects have included one-person exhibitions of artists such as Nayland Blake, Lee Boroson, Joseph Grigely, Jim Hodges, Nina Katchadourian, Martin Kersels, Alyson Shotz, Shahzia Sikander, and Amy Sillman. Recent publications include *Kara Walker: Narratives of a Negress* (2003, 2008), *Richard Pettibone: A Retrospective* (2005), *America Starts Here: Kate Ericson and Mel Ziegler* (2006), and *Dario Robleto: Alloy of Love* (2008). Berry has chaired the visual arts panel of the New York State Council on the Arts and serves on the artistic advisory committee for Art21: Art in the Twenty-First Century and the ICI Exhibitions Committee.